GREEN BAY PACKERS
LEGENDS IN GREEN AND GOLD

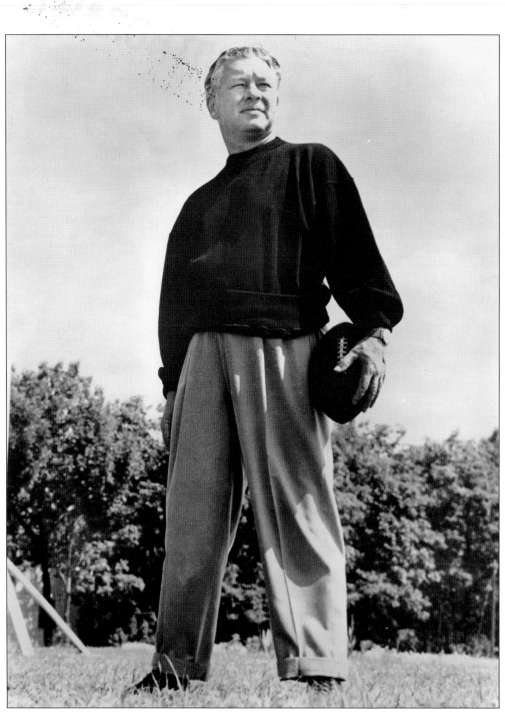

Photograph of Curly Lambeau courtesy of the Green Bay Packers Hall of Fame.

GREEN BAY PACKERS
LEGENDS IN GREEN AND GOLD

William Povletich

ARCADIA
PUBLISHING

Published by Arcadia Publishing
Charleston, South Carolina

Printed in the United States of America

Library of Congress Catalog Card Number: 2005928707

For all general information contact Arcadia Publishing at:
Telephone 843-853-2070
Fax 843-853-0044
E-mail sales@arcadiapublishing.com
For customer service and orders:
Toll-Free 1-888-313-2665

Visit us on the Internet at www.arcadiapublishing.com

CONTENTS

ACKNOWLEDGMENTS

As an Emmy nominated documentary producer, I have had the privilege of collaborating with many wonderful historians, experts and contributors to make many projects a success. This book is no different. If it were not for the unbridled cooperation of Cliff Behnke and Ron Larson at the Wisconsin State Journal, Chris Callies of Harmann Studios, Jacqueline Frank at the Neville Public Museum, Tom Murphy of the Green Bay Packers Hall of Fame, Chip Manthey, Matt Kerschner, Ken Zugbaum and Mary Jane Phillips, this book would have never seen the light of day. Thanks to the generosity and honesty of Jeff Ash at the *Green Bay Press-Gazette*, this book avoided becoming a grammatical nightmare. The passionate sharing of Packer knowledge from Tom Pigeon prevented this book from becoming a historical catastrophe. Without Jason Christopherson, author of Arcadia Publishing's *Baseball in Eau Claire*, I may have never met my acquisitions editor, Jeff Ruetsche, and the wonderful staff at Arcadia who have been nothing but unconditionally supportive throughout this entire process. And if it were not for my high school art teacher, Sarah Krueger, I may have never found the match to light my flame of ambition.

On a personal note, I want to thank my numerous guardian angels including Christopher Tricarico, Steve Brettingen, my parents William and Abigail, brother David, in-laws Stephen and Patricia Diercks and brother Andrew, who helped me realize this lifelong dream of writing a book on the history of the greatest sports franchise in the world. I also want to thank some of my favorite uncle-in-laws, pictured below wearing Packers jackets, who provided me with lifelong memories of witnessing Green Bay's march to Super Bowl XXXI at Lambeau Field from their 50-yardline seats. And I want to thank my wonderful wife Katherine, without whom, I never would have realized life's greatest potentials.

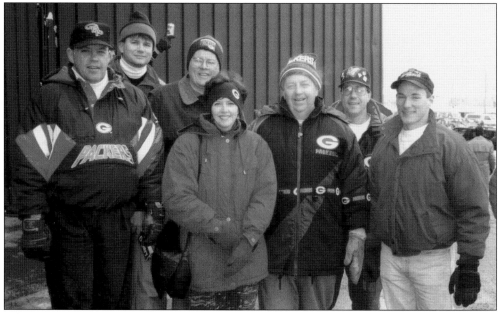

(Photograph courtesy of Matt Kerschner.)

INTRODUCTION

Their football legacy is second to none—12 NFL championships, 25 Hall of Famers, and names like Lombardi, Lambeau, and Favre that are synonymous with a winning tradition. In a day where big money and ever-increasing television markets dictate escalating player salaries and team relocations, the Green Bay Packers continue to succeed as a professional sports anomaly. While surviving certain bankruptcy, enduring numerous seasons of mediocrity and playing in the smallest market of any major sports team in America, the Green Bay Packers have risen to become recognized as one of the greatest franchises in sports history.

The fact that these achievements have come while representing a community of approximately 100,000 residents and competing against teams from the country's largest cities, the Green Bay Packers have endeared themselves to the nation's football fans as the only publicly owned sports franchise in the United States.

Green Bay Packers: Legends in Green and Gold chronicles the team's phenomenal successes, heartbreaking letdowns, and legendary moments from their inauspicious inception in 1919 to their unprecedented 12th NFL championship against the New England Patriots in Super Bowl XXXI. Through the use of rare photographs, the Packers colorful history will showcase the classic story of David versus Goliath played out on the professional football gridirons of the 20th century.

Photograph of Curly Lambeau courtesy of the Green Bay Packers Hall of Fame.

ONE

Birth of a Legacy
The Curly Lambeau Era
1919–1949

Those who witnessed the early years of the Green Bay Packers on such gridirons as the Polo Grounds, Wrigley Field, and Griffith Stadium usually looked upon them as a colorful and gutsy team from that little town in Wisconsin. Even though the Packers had found success in their first two seasons as a town team, there was a definite big-city disdain for their civic pride background when they entered the new national professional football league in 1921. Many questioned how Green Bay would produce a top-flight franchise in such a small community compared to the financially secure teams from Chicago and Minneapolis.

Those big-city owners had reason to question the Packers' ambitious leader, Earl "Curly" Lambeau, when he applied for a franchise. Aside from Green Bay, the smaller communities that supported professional teams during those formative years all eventually folded under the financial pressures. Within a few years of entering what became the NFL, teams from Muncie, Indiana; Akron, Ohio; and Rock Island, Illinois, were no more. If the Packers were to survive in professional football, the team would have to prove itself immediately and wouldn't be afforded a second chance.

FOOTBALL PLAYERS CALLED FOR MEET ON FRIDAY NIGHT

Indian Packing Corporation Squad to Gather at Press-Gazette at 7:45.

Footballers on the Indian Packing Corporation squad will hold an important meeting in the editorial rooms of The Press-Gazette on Friday evening at 7:45. It is of utmost importance that every man be on hand as final plans for the season will be outlined.

The footballers will hold their first practice on Sept. 3, the Wednesday after Labor Day. Negotiations have been practically completed for the opening game on Sunday, Sept. 14.

The uniforms, which are being furnished by the Indian Packing Corporation, will be here in time for the opening game and the "Packers" will be outfitted in college style.

Many of the best teams in the state want to be seen in action here this season. Inquiries about games have been received from Milwaukee, Racine, Kenosha, Waukesha, La Crosse, and Madison. Marinette, Menominee, Oconto, Oshkosh and Appleton will play in Green Bay during the fore-

The inauspicious beginnings of the Green Bay Packers can be traced back to the evening of August 11, 1919. Leaving Notre Dame after his freshman year of college to work at the local Indian Packing Company, Earl "Curly" Lambeau longed to continue playing the game he loved as a star athlete at Green Bay's East High School. (Photograph courtesy of the Green Bay Packers Hall of Fame.)

Along with local sports editor George Calhoun, Lambeau gathered together a group of local athletes in the editorial room of the old Green Bay Press-Gazette building. It was during this initial meeting that the foundation was laid to create the Green Bay Packers football organization. (Photograph courtesy of the Green Bay Packers Hall of Fame.)

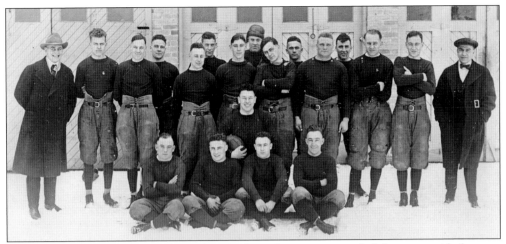

Curly's employer at the time, the Indian Packing Company, provided the team with finances for team jerseys and equipment. Because of the initial sponsorship, the club was immediately identified in its early publicity as a project of the company. The tie-in name, Packers, quickly became a natural fit as a team nickname. Lambeau, a Notre Dame alum, chose his alma mater colors of blue and gold for the team uniforms. (Photograph courtesy of the Green Bay Packers Hall of Fame.)

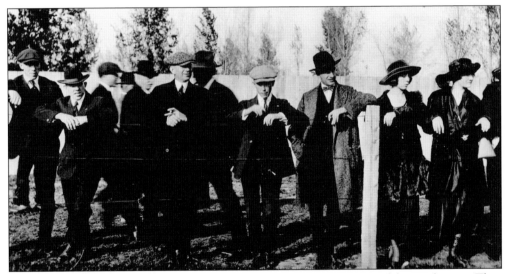

In the Packers inaugural season of 1919, the team won 10 games and lost only one. They competed against other town teams from Wisconsin and Upper Michigan. In a very casual atmosphere, games were played in open fields as interested fans "passed the hat" to financially support their favorite team. There were days when the collected sums reached upwards of $200. At season's end, each Packer received a magnificent sum of $16.75 and anxiously awaited the start of the 1920 season. (Photograph courtesy of the Green Bay Packers Hall of Fame.)

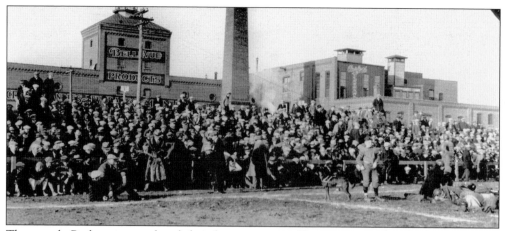

Those early Packers teams played their home games at Hagemeister Park, which was nothing more than a big vacant lot with a football gridiron marked on it. The modest field had no ushers, no cheerleaders, no bands and no seats. Most fans parked their cars and watched or stood alongside the sidelines practically spilling out onto the field of play. Despite a successful campaign in 1920 that saw the Packers outscore their opponents 227-24, the cash ledgers showcased nothing. (Photograph courtesy of the Green Bay Packers Hall of Fame.)

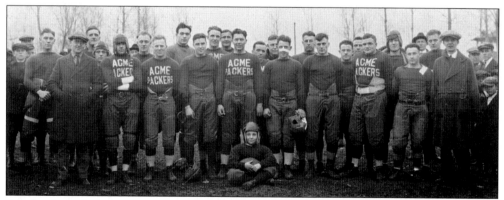

But thanks to their success as a town team, Lambeau was backed by two officials of the packing plant and obtained a franchise in the newly formed American Professional Football Association. As the 1921 season progressed, the Packers soon discovered that passing the hat didn't quite pay the bills in the pros. After only one season, the team was deep in debt and the professional football franchise was forfeited at year's end. (Photograph courtesy of the Neville Public Museum of Brown County.)

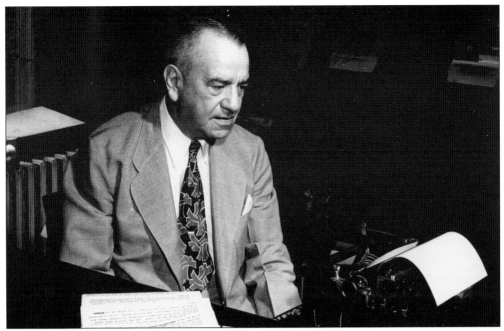

It was the first in a long series of monetary troubles for the small-town Packers. With the help of the Press-Gazette's sports editor George Calhoun, Lambeau recruited other financial backers and bought the franchise back for $250, in time for the newly reorganized and renamed National Football League's 1922 season. Later that year, the Packers canceled a game due to inclement weather—a decision that almost broke the franchise for good. It was later discovered that the team's insurance policy would not provide compensation, because the rain total was one-hundredth of an inch short of the policy's requirement. (Photograph courtesy of the Green Bay Packers Hall of Fame.)

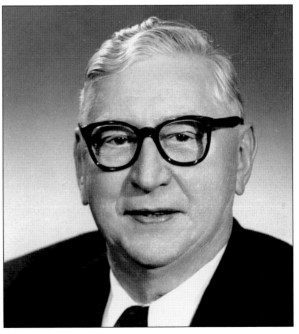

Thanks to the strong guidance of A. B. Turnbull, general manager of the *Green Bay Press-Gazette*, the local businessmen of Green Bay organized to support the financially flailing team during the 1922 season. It was through their efforts that the resourceful backers, known as the Hungry Five, formed the Green Bay Football Corporation. They raised $5,000 in capital by selling 1,000 stock shares at five dollars apiece. The original articles of incorporation for the (then) Green Bay Football Corporation were put into place by 1923. (Photograph courtesy of the Green Bay Packers Hall of Fame.)

The Articles stated that if the Packers franchise was ever sold, after the payment of all expenses, any remaining monies would go to the Sullivan-Wallen Post of the American Legion in order to build "a proper soldier's memorial." With no financial incentives for shareholders to sell, the stipulation ensured that the club would always remain in Green Bay. (Photograph courtesy of the Green Bay Packers Hall of Fame.)

Despite the team's new-found incorporation, they still struggled to schedule games at venues that could guarantee profitable payouts. Regardless of the Packers affiliation with the upstart National Football League, professional football wasn't considered a lucrative business during those formative years. Working from his office at the Press-Gazette, which also doubled as the Packers' corporate office at the time, George Calhoun lobbied for opportunities to showcase the team wherever he could to keep the franchise afloat. (Photograph courtesy of the Green Bay Packers Hall of Fame.)

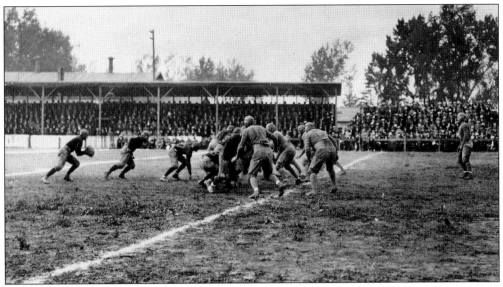

With Curly Lambeau calling the plays behind center, the Packers were attracting energetic crowds of 4,000 to 5,000 fans at Green Bay's Bellevue Park. As the crowds began to spill onto the field, especially to boo the archrival Chicago Bears, it was decided a new football facility had to be constructed to contain the enthusiastically growing fan base. (Photograph courtesy of the Green Bay Packers Hall of Fame.)

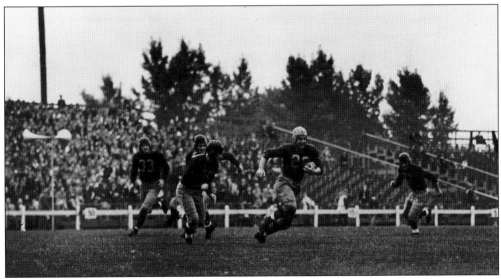

Completed just in time for the start of the 1925 season, the original City Stadium drew a record crowd of 5,389 for the annual game against the Bears. The Packers truly enjoyed their new home field that season by going undefeated, 6-0, and drawing over 21,000 fans. (Photograph courtesy of the Green Bay Packers Hall of Fame.)

Thanks to the strong attendance figures and corresponding financial backing, Lambeau was able to recruit and sign college stars from all over the country during the next few years. His knack for finding talent was uncanny and unrivaled. Prior to the start of the 1929 season, Lambeau was able to land three future Hall of Famers—Mike Michalske, Cal Hubbard and Johnny "Blood" McNally—to a club that had finished among the top five teams in the league, three years running. With the talent-laden roster, Lambeau retired as the Packers quarterback and focused on coaching the team to their first world championship. (Photograph courtesy of the Green Bay Packers Hall of Fame.)

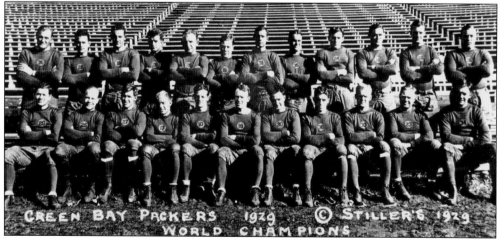

Trailing only once all season, the highly skilled Packers went an astounding 12-0-1 during league play in 1929 with the only blemish being a 0-0 tie to the Frankford Yellow Jackets in the fourth to last game of the year. By finishing with the best regular season record, the team was crowned NFL champions. It was the first title for the small Wisconsin community soon to be known around the world as Titletown, U.S.A. (Photograph courtesy of the Green Bay Packers Hall of Fame.)

After repeating as NFL champions in 1930, the Packers won an unprecedented third consecutive NFL championship in 1931. During that three-year stretch, Green Bay won an impressive 34 games while only losing five and tying two. Those Packer teams included some of the all-time greats from the Iron Man era of professional football legends like Red Dunn, Verne Lewellen, Cal Hubbard, Bo Molenda, Jug Earp, Mike Michalske, Johnny "Blood" McNally, Arnie Herber, Lavvie Dilweg, Tom Nash, Milt Gantenbein, and Hank Bruder. (Photograph courtesy of the Green Bay Packers Hall of Fame.)

One of the biggest contributors to the Packers' three straight world championships was born in the small northwestern Wisconsin community of New Richmond. Johnny "Blood" McNally played 14 seasons in the NFL as an elusive runner and gifted receiver. While still in college, McNally decided to take a shot at professional football and needed an alias to protect his eligibility. When McNally and a friend saw the Rudolph Valentino movie, *Blood and Sand*, he and the friend decided, "That's it. You be Sand, I'll be Blood." So Johnny Blood it was. Even though some of his off-the-field exploits overshadowed his production on the field, McNally was able to run, pass, and punt with the best of them, and emerged as one of the best pass-catching backs in the league during the Iron Man era. As a vital contributor to four of Green Bay's championship teams, McNally was one of four Packers inducted into the inaugural Pro Football Hall of Fame class of 1963. (Photograph courtesy of the Green Bay Packers Hall of Fame.)

Wanting out of New York, the underutilized Robert "Cal" Hubbard was acquired by Curly Lambeau via a trade from the Giants and made an immediate impact in 1929. Hubbard was an awesome combination for a tackle—size and speed. A devastating blocker on offense and a relentless pursuer on defense, he was the cornerstone of the Packers' three championships in 1929, 1930, and 1931. During the summers in Green Bay, Hubbard began umpiring baseball games and by 1936, he began a new professional career as an American League umpire. In 1958, Hubbard was appointed umpire-in-chief of the American League and holds the distinction of being the only person enshrined in both the Baseball and Pro Football Hall of Fames. (Photograph courtesy of the Green Bay Packers Hall of Fame.)

For 11 years Mike Michalske was professional football's premier guard. Particularly adept at going after the passer, Michalske championed the idea of using former fullbacks at guard because of their elusive speed and explosiveness. Thanks to his success, it was no accident that many fine Green Bay guards first played fullback before Lambeau switched them to guard. Known around the league as Iron Mike, Michalske played 60 minutes every game and was never injured. "I just didn't get hurt," he explained. "The players used to say I must have been getting paid by the minute." Recognized as the anchor of the Packers' lines during their championship run of 1929 through 1931, he was elected as the first guard to the Pro Football Hall of Fame in 1964. (Photograph courtesy of the Green Bay Packers Hall of Fame.)

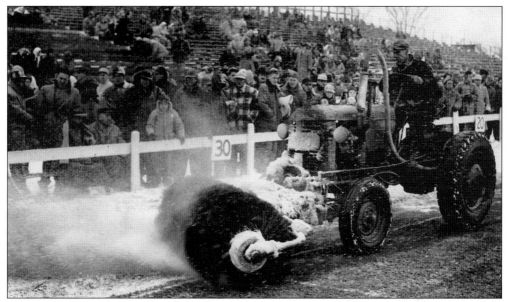

Fresh from their championship run, the team found itself in financial jeopardy yet again by 1933. The major blow struck when a spectator fell from the temporary wooden bleachers at City Stadium and won a $5,000 settlement. Shortly after the accident, the Packers insurance firm went bankrupt. The team was forced into receivership and was on the verge of folding yet again. (Photograph courtesy of the Green Bay Packers Hall of Fame.)

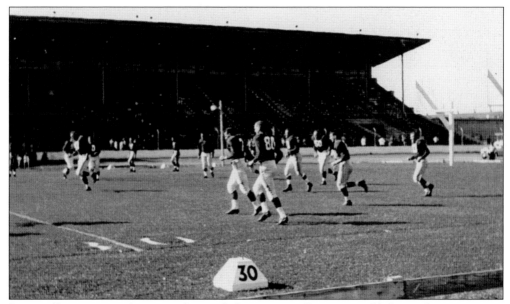

In an effort to tap a larger market and thwart any efforts to establish another competing pro football team in Milwaukee, the Packers began playing a portion of their home games at Borchert Field in 1933 and moved to the Wisconsin State Fairgrounds in 1934. Over a 62-year span through 1994, the Packers would host over 300 home games in the state's largest metropolis. Despite their new revenue opportunities in Milwaukee, the Packers struggled on the field. (Photograph courtesy of the Green Bay Packers Hall of Fame.)

After posting a disappointing 5-7-1 record in 1933 and a lackluster 7-6 record in 1934, the Packers were forced once again to call upon the community to help save it from disbanding. As in years past, the Hungry Five came to the rescue with the second stock drive in franchise history. They raised $15,000 in new capital while reorganizing the team. On January 25, 1935, three members of the Hungry Five formulated the Green Bay Packers, Incorporated with one of the most unique documents in professional sports. It was a veritable Declaration of Independence that marked the team's resurrection as a publicly-owned, non-profit corporation and financially sound organization. With the fiscal backing to compete alongside big city teams, Lambeau relied on his abilities to find good talent to keep his Packer teams competitive. Had it not been for a unique decision by NFL president Joe Carr, the Packers might have never acquired the landmark pass-catcher who would redefine a team, a league and the way the game was played. (Photograph courtesy of the Green Bay Packers Hall of Fame.)

After college, Don Hutson inadvertently signed contracts with both the pass-minded Packers and the NFL's Brooklyn Dodgers, a team that rarely passed. To resolve the situation in the fairest way possible, Carr ruled that the contract with the earliest postmark would be honored. The Packers contract was postmarked 8:30 a.m.—17 minutes earlier than the Dodgers' pact. Thus, Hutson became a Packer and his career statistics began to mount from there. (Photograph courtesy of the Green Bay Packers Hall of Fame.)

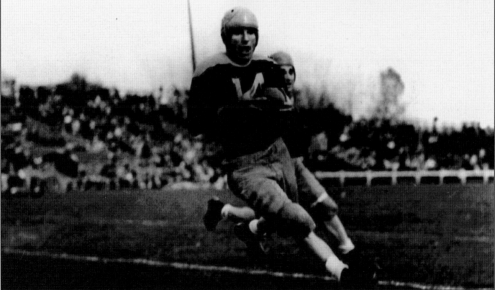

Hutson's impact on professional football was immediate. His first touchdown catch came on an 83-yard pass from Green Bay quarterback Arnie Herber in just his second game with the Packers. Credited with inventing modern pass receiving with Z-outs, buttonhooks, hook-and-go routes, along with a whole catalog of moves and fakes, it was not long before Hutson's mere presence on the field changed the concept of defending the pass. (Photograph courtesy of the Green Bay Packers Hall of Fame.)

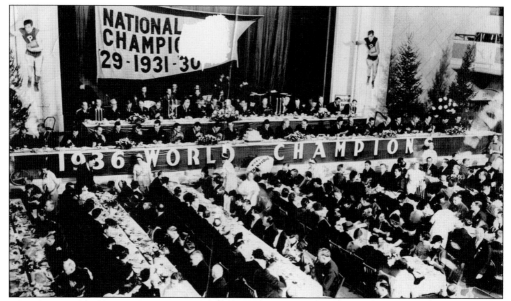

Thanks in part to Hutson's success, the Packers' attendance numbers grew and the team was able to buy itself out of receivership in 1935. Led by future Hall of Famers Hutson, McNally, Herber and Clarke Hinkle, Green Bay's record-setting passing attack helped whip the Boston Redskins 21-6 in the Packers' first title game. With the victory, Green Bay claimed their fourth NFL championship in 1936 and celebrated at a banquet in the team's honor. (Photograph courtesy of the Green Bay Packers Hall of Fame.)

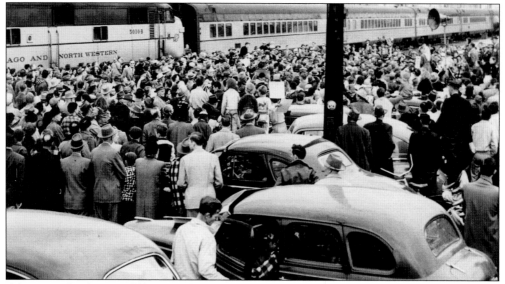

After a couple of seasons falling just short of winning their unprecedented fifth NFL championship in 11 years, the Packers' faithfuls were rewarded on December 10, 1939. More than 32,000 football fans witnessed Green Bay defeat the Giants with the first postseason shutout in NFL history, 27-0 at State Fair Park in Milwaukee. The Packers dominated that afternoon by intercepting the New Yorkers six times and holding them to just 164 total yards. After the victory, the Green Bay community could not wait to celebrate once the team arrived back in town as world champions. (Photograph courtesy of the Green Bay Packers Hall of Fame.)

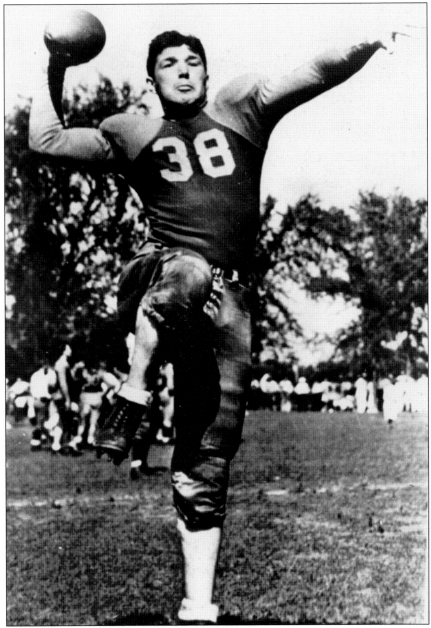

It had been nearly a decade since Curly Lambeau retired as the Packers' primary signal caller and replaced himself at quarterback with Arnie Herber. When the coach decided to give the local Green Bay native, who was working as a handyman around the Packers' clubhouse, a tryout, it was the birth of another Packer legend. For $75 a game, the Packers unearthed the first pro quarterback who consistently used the forward pass with game-winning effectiveness. Behind Herber's golden arm, the Packers won NFL titles in both 1930 and 1931 and remained in a perpetual contending position throughout his 11-year tenure. With the arrival of Don Hutson in 1935, Green Bay gave pro football its first lethal quarterback-receiver tandem and earned Herber an invitation into the Pro Football Hall of Fame in 1966. (Photograph courtesy of the Green Bay Packers Hall of Fame.)

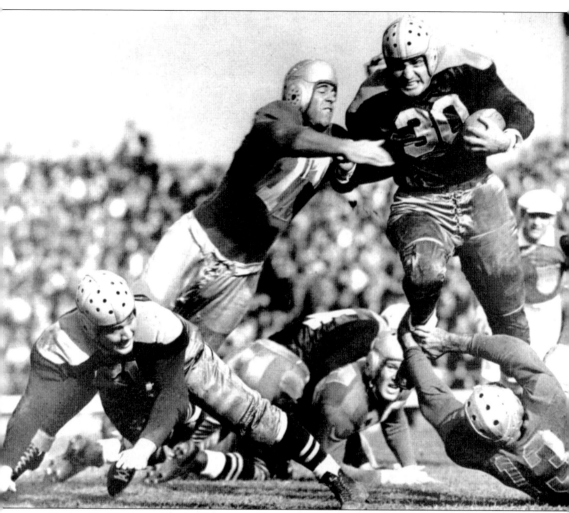

During his 10 years with the Green Bay Packers, Clarke Hinkle (30) was named first or second team All-League each year. When he retired after the 1941 season, Clarke Hinkle was the leading rusher in NFL history. But he is best remembered for his head-to-head duels with another great fullback/linebacker, Bronko Nagurski of the Chicago Bears. Nagurski was the prototype power runner of the 1930s, but the rugged, 30-pounds lighter Hinkle, was determined to hold his own with anyone on an NFL gridiron. Hinkle was elected to the Pro Football Hall of Fame in 1964 and his respected rival, Bronko Nagurski, gave his introduction speech. (Photograph courtesy of the Tom Pigeon collection.)

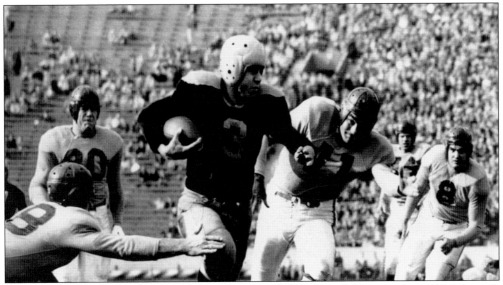

The road to the postseason in the Western Division went through Chicago from 1940 through 1943. The Packers finished a close second in each of those four seasons, but couldn't seem to break through the Bears' gridiron dominance. As World War II continued to impact NFL rosters in 1944, hundreds of players were stationed overseas, including 35 with ties to the Packers. Green Bay's Tony Canadeo (3), an army corporal, was granted a short leave and played in three games to help the Packers secure their first postseason berth since 1939. (Photograph courtesy of the Green Bay Packers Hall of Fame.)

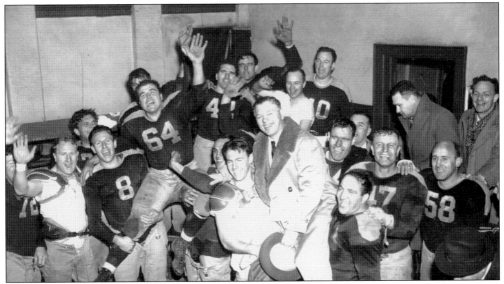

With an 8-2 regular season record in 1944, Green Bay seized the opportunity to win their sixth NFL title under Curly Lambeau. The Packers defeated the Giants, 14-7, in front of over 46,000 screaming New Yorkers. With Hutson used primarily as a pass-catching decoy, fullback Ted Fritsch emerged as the Packers' offensive hero that day by scoring both of the team's touchdowns. Despite the fact that it was Lambeau's final NFL championship, the Packers celebrated in the locker room afterwards as if it were the team's first. (Photograph courtesy of the Green Bay Packers Hall of Fame.)

When Don Hutson retired following the 1945 season, he held 18 NFL records, including 488 career receptions and an unprecedented 99 career touchdown receptions—a record that stood for over four decades and was 200 more than his closest competitor. While leading the NFL in receiving during 8 of his 11 seasons, Hutson won the scoring title five straight years. Twice, in 1941 and 1942, he was named the league's MVP and was inducted into the inaugural Pro Football Hall of Fame class of 1963. (Photograph courtesy of the Green Bay Packers Hall of Fame.)

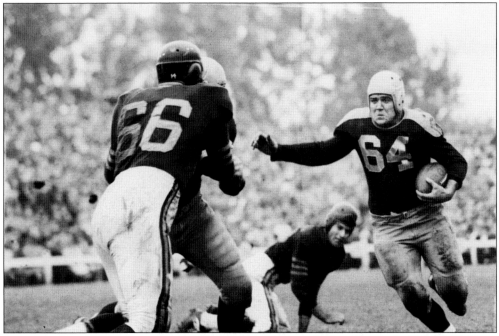

Following Don Hutson's retirement, Green Bay's fortunes declined on and off the field. From 1946 through 1948, the financially strapped Packers lost two of their three number one draft choices to the upstart All-America Football Conference (AAFC) Unable to bid with the rival league, the Packers couldn't replenish their aging roster and lost ground in the standings. The disastrous pro football war between the NFL and the AAFC brought on another monetary crisis following the 1949 season. (Photograph courtesy of the Neville Public Museum of Brown County.)

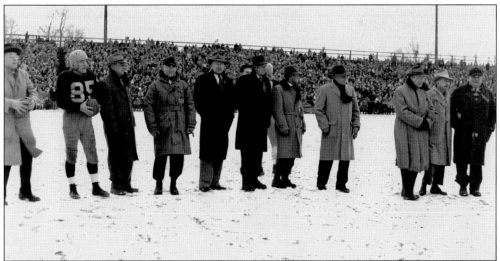

Desperate for new income, the Packers held an old-timers game and intra-squad scrimmage on Thanksgiving Day in 1949. The game raised nearly $50,000—enough to keep the team operating and finish the season. Despite the success of the fund-raiser, it didn't help the Packers to a winning record that season. The team's 2-10 record was the worst in Lambeau's three decades as coach. (Photograph courtesy of the Tom Pigeon collection.)

With the Packers struggling both financially and in the standings since their championship season of 1944, Curly Lambeau became a lightning rod of controversy by 1949. In the midst of turbulent times, Green Bay's only head coach in team history lost an internal power struggle with the Packer organization. The dispute ultimately began when he used $25,000 of franchise funds to purchase Rockwood Lodge for the team's training camp facility. The dispute ultimately ended on January 31, 1950, when Curly Lambeau unceremoniously resigned to become head coach of the Chicago Cardinals. (Photograph courtesy of the Green Bay Packers Hall of Fame.)

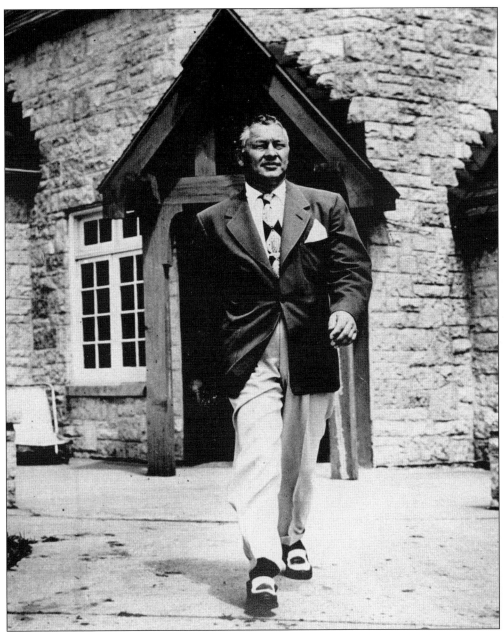

The resignation marked the end of Earl "Curly" Lambeau's 31-year run in Green Bay. Under his visionary leadership, the Green Bay Packers became one of professional football's first great dynasties. More than any other person, he was responsible for their unique existence as a small-town franchise. As the team's only head coach from 1919 through 1949, he led the Packers to six world championships and a 212-106-21 record. Elected to the Pro Football Hall of Fame's inaugural class in 1963, Lambeau will always be celebrated as one of the great innovators and early pioneers of professional football. Regardless of Lambeau's career accolades, the Packers were facing an uncertain future prior to the 1950 season. Losing the only head coach the team had ever had, Green Bay was in need of a leader who could return the franchise to championship form in the ensuing decade. (Photograph courtesy of the Green Bay Packers Hall of Fame.)

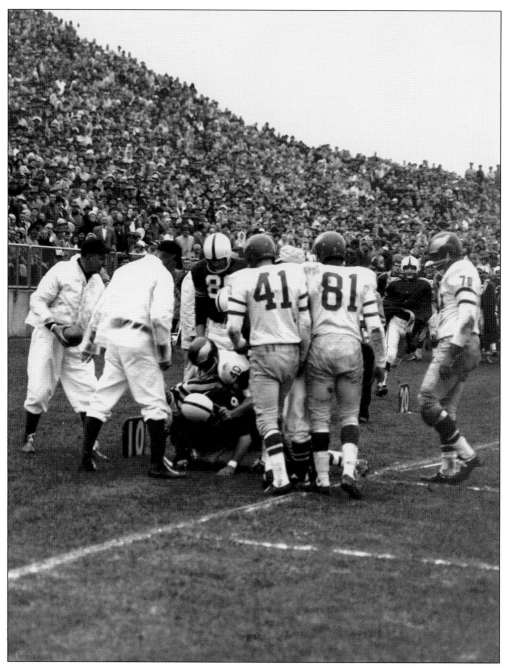

Photograph of the Packers during the 1950s courtesy of the Tom Pigeon Collection.

TWO

Navigating through Mediocrity
The Lean Years
1950–1958

The late 1940s and 1950s found the popularity of professional football growing at an exponential rate. The league had successfully expanded into the bustling metropolises of Philadelphia, Baltimore, Los Angeles and Pittsburgh. Marking an end to the first battle against a rival league, the NFL incorporated the Cleveland Browns, San Francisco 49ers, and Baltimore Colts into their elite ranks after the AAFC disbanded following the 1949 season. The future looked bright for the NFL, but one of its oldest franchises found itself struggling to compete yet again.

The 1950s were spent with the Packers chasing the NFL's best. After the scandalous departure of Curly Lambeau following the 1949 season, the team struggled to find a definitive direction on and off the field. With numerous head coaching changes, roster overhauls and financial limitations, the Packers were in disarray. Many questioned if the team would be able to survive through the end of the decade.

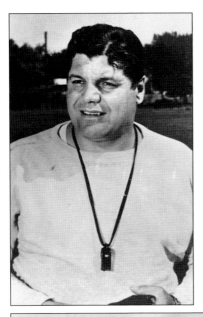

To replace the recently departed Curly Lambeau, the Packers hired Gene Ronzani, an ex-Chicago Bears star, as head coach and vice-president of the organization. Under Ronzani's leadership, Packers fortunes continued to spiral downward on and off the field. (Photograph courtesy of the Green Bay Packers Hall of Fame.)

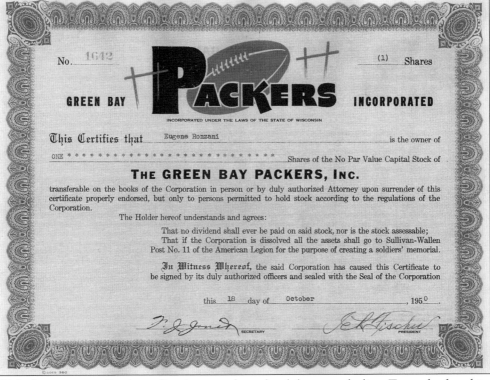

With the team struggling in mediocrity, attendance levels began to decline. To get the franchise back on firm financial footing in 1950, the team publicly offered stocks. Even though the stocks offered no dividends, residents of Green Bay and the rest of Wisconsin rushed to own a piece of the team at $25 per share. Netting nearly $118,000, the stock drive guaranteed the team would continue to survive in Green Bay. (Photograph courtesy of the Green Bay Packers Hall of Fame.)

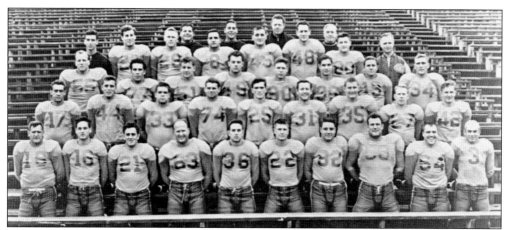

In an effort to distance themselves from their departed founder, the Packers changed their team colors to green and gold in 1950 while eliminating the navy blue. With their new uniforms, rejuvenated financial opportunities, and a rookie coach, the Packers looked forward to returning to the NFL elite as the new decade began. (Photograph courtesy of the Neville Public Museum of Brown County.)

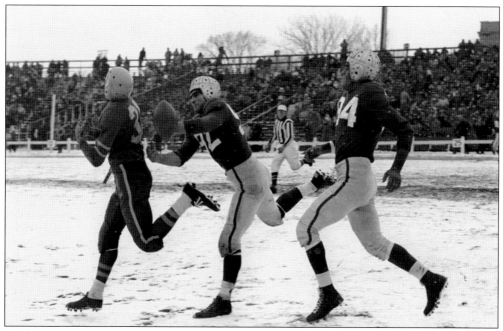

Under Ronzani's leadership, the team seemed to turn over roster spots off the field as often as they turned the ball over on the field. Only about a third of the new coach's 1950 roster had ties to the Lambeau era. Even though the Packers continued to improve during each of his first three seasons, Ronzani and the Packers weren't able to seriously compete for an NFL championship. Despite the team's inability to consistently win, the Packers continued their tradition of showcasing Hall of Fame talent between the hash marks. (Photograph courtesy of the Tom Pigeon Collection.)

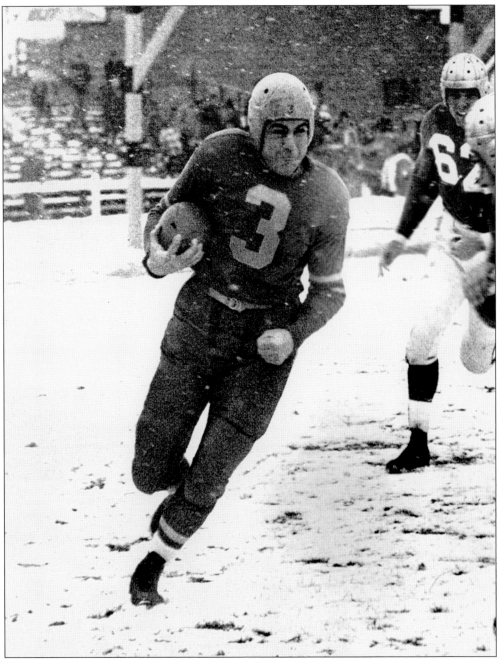

Tony Canadeo quickly earned the reputation of being a superstar who could—and would—do anything on a football field to win. As an unsung ninth-round draft choice of the Green Bay Packers in 1941, the versatile Canadeo gained 8,667 multi-purpose yards in 11 seasons. In 1949, he became only the third player to rush for more than 1,000 yards in a season. The durable, all-purpose halfback was a 1974 selection to the Pro Football Hall of Fame. (Photograph courtesy of the Green Bay Packers Hall of Fame.)

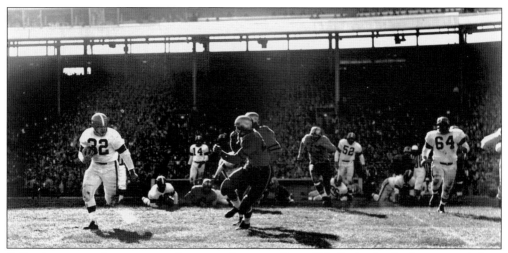

Following years of great games by great players at State Fair Park, the Packers moved their southeastern Wisconsin contests to the newly constructed Milwaukee County Stadium in 1953. Starting with the season opener against the Cleveland Browns on September 27, the Packers began a fine tradition of hosting a portion of their home games in front of their loyal Milwaukee fans. For the next four decades, the Packers would share the same venue that was home to baseball greats Henry Aaron, Eddie Mathews, Warren Spahn, Paul Molitor, and Robin Yount. (Photograph courtesy of the Tom Pigeon collection.)

Despite the contributions of future Hall of Famers and new surroundings in Milwaukee, the Packers' fortunes did not improve. Ronzani's teams continued to play inconsistent and erratic football during his four seasons in Green Bay; play that reflected in his 14-31-1 coaching record. Unable to answer his detractors, Gene Ronzani became the first and only head coach in team history to resign during the course of a season. (Photograph courtesy of the *Green Bay Press-Gazette*.)

After Ronzani's abrupt departure, assistant coaches, Hugh Devore (pictured far left) and Ray "Scooter" McLean (pictured far right), served as co-head coaches for the remaining two games of the 1953 season. Despite the coaching change, Green Bay's resolve continued to decline as the dual coaches finished 0-2 that season. With an overall record of 2-9-1, the Packers were yet again stagnant and in last place. (Photograph courtesy of the *Green Bay Press-Gazette*.)

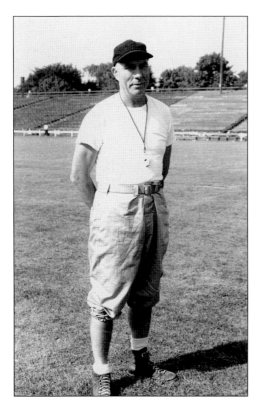

In an attempt to jumpstart the franchise's hopes in 1954, the Packers overhauled their front office and coaching staff. The team's coaching search didn't even leave the state of Wisconsin when Lisle Blackbourn was hired out of the college ranks from Milwaukee's Marquette University. Green Bay quickly realized that Blackbourn's college success didn't calculate into wins during his inaugural season in the pros. The team was incapable of winning close games as they lost six contests by seven points or less. (Photograph courtesy of the Green Bay Packers Hall of Fame.)

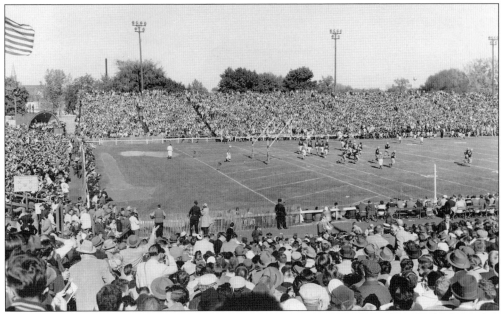

The Packers seemed to be improving under Blackbourn in 1955 when they finished 6-6, but a disappointing 4-8 record in 1956 seemed to squash even the most optimistic of Packer fan hopes. As NFL franchises continued to succeed in larger markets, the Packers realized that if they wanted to compete, they'd need a new, larger, state-of-the-art stadium. (Photograph courtesy of the Green Bay Packers Hall of Fame.)

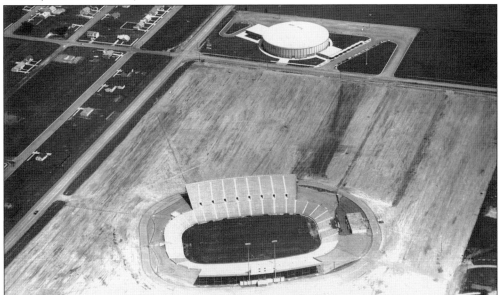

Once again the community rallied around the Packers. On April 3, 1956, voters approved a referendum to fund construction on a new stadium in Green Bay. Less than 18 months after the referendum passed, Green Bay's new football home was erected. On September 29, 1957, a day that saw the Packers topple the rival Bears 21-17 in the season opener, the new City Stadium was officially dedicated. (Photograph courtesy of the Neville Public Museum of Brown County.)

The Packers had hosted season-openers before, but none with the pomp and pageantry of new City Stadium's dedication. The ceremonies were attended by Vice Pres. Richard Nixon, Miss America, television star James Arness and National Football League Commissioner Bert Bell. The win against the Packers' oldest and most hated rival, the Chicago Bears, made the weekend all the more memorable. (Photograph courtesy of the Green Bay Packers Hall of Fame.)

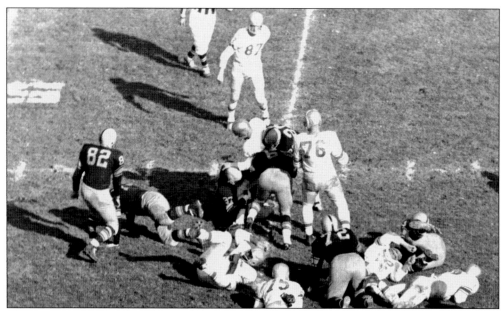

Unfortunately, the 1957 home opener was the Packers only win in front of the Green Bay faithful that season. Finishing the season with a disappointing 3-9 record, Lisle Blackbourn was unceremoniously fired at season's end with a 17-31 record in four campaigns as the Packers' head coach. As turbulent as his tenure in Green Bay was, Blackbourn oversaw the drafts that acquired some of the most legendary players to ever sport green and gold including Paul Hornung, Forrest Gregg, Ray Nitschke and Bart Starr. (Photograph courtesy of the Tom Pigeon collection.)

After years of being a loyal, likeable, and outstanding assistant coach, Ray "Scooter" McLean was given the chance to guide the destiny of the Packers in 1958. Following a disastrous 1-10-1 record—the worst in Packer history—McLean resigned as head coach in December. The team hadn't finished a season above .500 for over a decade since Curly Lambeau was coach. A national general manager and coaching search to revive the struggling franchise was initiated. (Photograph courtesy of the Green Bay Packers Hall of Fame.)

Spanning across the entire football landscape from the Canadian Football League to the college ranks, the general manager and coaching search even prompted an application from Packers founder, Curly Lambeau. What the Packers found was a hard-working assistant coach with the New York Giants who yearned to prove himself with an opportunity to be a head coach in the NFL. (Photograph courtesy of the Green Bay Packers Hall of Fame.)

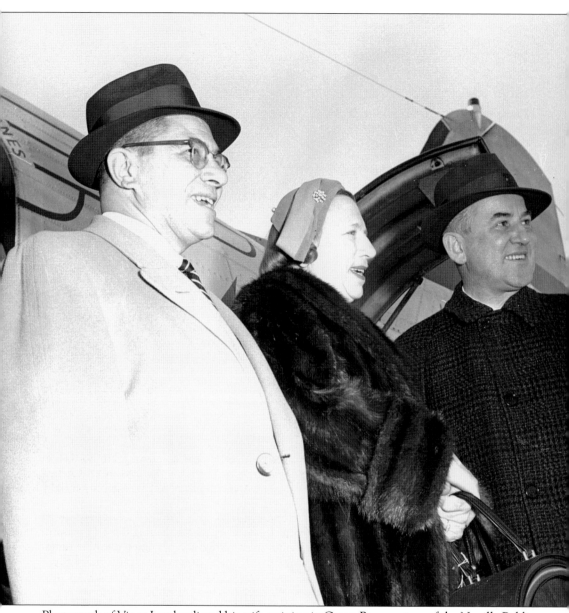

Photograph of Vince Lombardi and his wife arriving in Green Bay courtesy of the Neville Public Museum of Brown County.

THREE

The Rise of Titletown, U.S.A.
The Vince Lombardi Era
1959–1967

The 1960s found the NFL and professional football experiencing unprecedented growth. Behind charismatic Commissioner Pete Rozelle, the NFL expanded from 12 to 26 teams, witnessed the signing of blockbuster television contracts, and engaged in a contract war with the rival American Football League. By the end of the decade the two leagues merged, but not before the creation of the Super Bowl as America's premiere sporting event. It was also under Rozelle's leadership that NFL owners agreed to equally share the television contract revenues, essentially securing the Packers' financial future forever.

As the new decade approached, the Packer organization was determined to end the losing attitude that had settled upon the franchise from 1948 through 1958. During those 11 seasons, Green Bay finished last or second-to-last in their respective division or conference nine times. Their 37 wins were the fewest of any team during that span. The team was clearly in disarray.

When team president Dominic Olejniczak recommended to the Packers a little-known New York Giants assistant coach on January 28, 1959, a fellow committee member replied, "Who the hell is Vince Lombardi?" The committee and the world soon found out. Within hours of his arrival in Green Bay on February 2, Lombardi told the committee, "I want it understood that I am in complete control here." Two days later, the Packers officially announced Vince Lombardi as Green Bay's new general manager and head coach.

On February 4, 1959, Vince Lombardi seized his opportunity and began building his football dynasty in Green Bay. He started by trading away the Packers best receiver of the decade, Bill Howton, to Cleveland. To bring some much-needed leadership to the defensive backfield, Lombardi obtained future Hall of Famer Emlen Tunnell from the Giants. He also acquired Fuzzy Thurston from the Colts and defensive tackle Henry Jordan from Cleveland by the start of training camp. In all, 16 veterans from the previous season were sent packing as Lombardi instilled a new attitude in the Packers' locker room. (Photograph courtesy of the Tom Pigeon Collection.)

Through his now legendary coaching style, Lombardi whipped the underachieving Packers into instant winners. He set his plan immediately into action at his very first team meeting. "I have never been on a losing team gentlemen and I do not intend to start now!" (Photograph courtesy of the Neville Public Museum of Brown County.)

The results of Lombardi's approach were dramatic. In the season opener against Chicago, the Packers held on to win 9-6 and celebrated the victory by carrying their new head coach off the field. In his first year on the sidelines, the Packers posted a 7-5 record—Green Bay's first winning season in 12 campaigns. The team's quick turnaround netted Lombardi unanimous honors as coach of the year. (Photograph courtesy of the *Green Bay Press-Gazette*.)

While wearing his general manager's hat, Lombardi saw statistical evidence of the difference a winning season made. The applications for season tickets in Green Bay increased from 25,000 to 31,000 prior to the start of the 1960 season—almost enough to fill the stadium for each home game. The time was about to arrive when a fan had to inherit the right to buy a season ticket and the public waiting list to receive an available seat was over 20 years long. (Photograph courtesy of the Tom Pigeon collection.)

As the team began to gain national attention, linebacker Ray Nitschke quickly earned the reputation of being an intimidating and indestructible force on the football field. One of the most evident stories that fueled his competitive toughness occurred during the 1960 training camp. While completing another session of Lombardi's intense workout drills, the Packers' coaching tower collapsed on top of Nitschke. As the structure buckled, a bolt from the metal works pierced his helmet. An accident that would have sidelined most men didn't phase the future Hall of Famer. In a turn of events that even impressed Lombardi, Nitschke grabbed another helmet and continued practice, unfazed. (Photograph courtesy of the Neville Public Museum of Brown County.)

Under the driving leadership of Vince Lombardi, the Packers rose from rags to riches after just two years. The 1960 team posted its most successful season in 15 years with an 8-4 record. As Western Division champions, the Packers earned their first title game appearance in 16 years against the Eastern Division champions, the Eagles. (Photograph courtesy of the *Green Bay Press-Gazette*.)

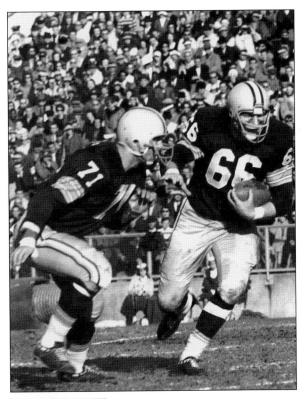

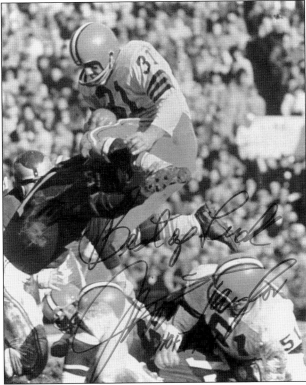

In an old-fashioned grudge match that played out on the slippery Franklin Field turf in Philadelphia, the Eagles and Packers played a game for the ages. Despite an early 6-0 lead in the second quarter, the Packers fell behind with a little over five minutes remaining. With Green Bay on the move and time winding down, Bart Starr fired a 15-yard pass to Jim Taylor (31) who was gang-tackled eight yards short of the goal line. The Eagles defense held the elusive Taylor as the gun sounded. The Packers lost the NFL championship 17-13, giving Lombardi his first—and only—post-season loss as the Packers' head coach. (Photograph courtesy of the Tom Pigeon collection.)

Haunted by the championship game defeat against the Eagles, Lombardi's will to win became not just a goal, but also a neurosis—an obsessive hatred of losing. His Packers didn't win it all and hadn't established the winning tradition of his sporting model of success, the New York Yankees. To prevent the Packers from believing they were sure winners, as the press and public had proclaimed, Lombardi made the team feel like underachievers and forced his players to work all that much harder. (Photograph courtesy of the Tom Pigeon collection.)

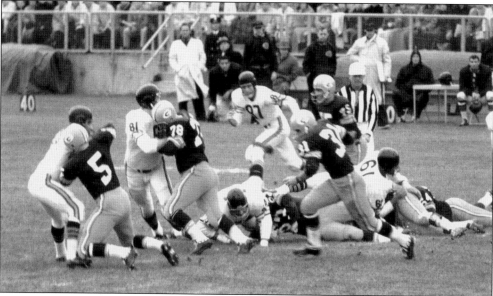

Lombardi continued to instill the Packer Sweep, a play that became the cornerstone on which his offense was built. The power sweep called for a running back to follow his pulling guards. Believing perfection was in the details, Lombardi had his team practice the play to the point where the offense could run it successfully even when the opposition knew it was coming. (Photograph courtesy of the Tom Pigeon collection.)

Lombardi's quest for perfection infused a new attitude and a new look at the start of the 1961 season. In prior years, the Packers had utilized a few different official logos, but only one—the "G" logo—ever made it onto the team's helmet. Designed by Green Bay's equipment manager Dad Braisher, the logo quickly became one of the most recognizable symbols in professional football and around the world. (Photograph courtesy of the *Green Bay Press-Gazette*.)

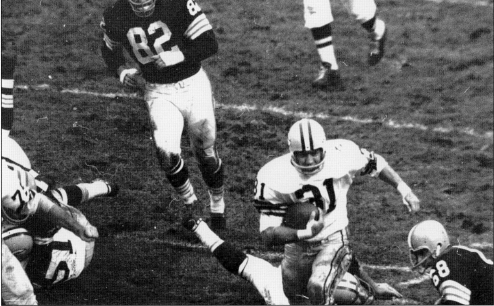

With a new determination and dedication to winning, Lombardi continued to push his team to new heights of success in 1961. Winning the Western Conference for the second consecutive year, the 11-3 Packers headed to their second straight NFL championship game against Lombardi's former employers, the New York Giants. (Photograph courtesy of the Tom Pigeon collection.)

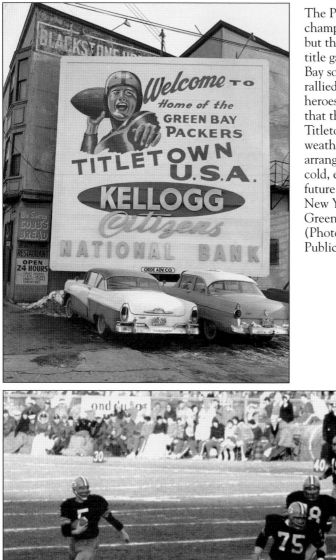

The Packers had won six league championships under Lambeau, but the 1961 game was the first title game to be played on Green Bay soil. As the entire community rallied around their local football heroes, banners went up bragging that the Packers resided in Titletown, U.S.A.. The town's weathermen did their best in arranging for several days of subzero cold, establishing a tradition for future playoff games and giving the New York visitors harsh evidence of Green Bay's home-field advantage. (Photograph courtesy of the Neville Public Museum of Brown County.)

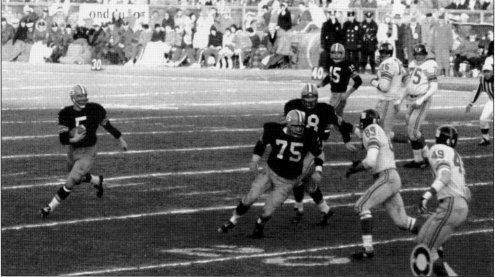

In front of over 39,000 boisterous Green Bay fans, the Packers routed the Giants 37-0, to win their first NFL championship under Lombardi. Paul Hornung (5) scored a record 19 points. Bart Starr, who'd been considered no better than a journeyman quarterback by the press out east, passed for three touchdowns against the New Yorkers. After surviving years of adversity and becoming philosophical about losing, Green Bay fans had reason to celebrate. They showed their appreciation by tearing down the goal posts after the game. (Photograph courtesy of the Tom Pigeon collection.)

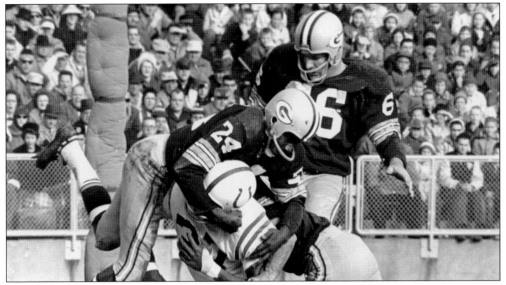

Regardless of their championship status, Vince Lombardi continued to preach perfection and his 1962 Green Bay Packers team came the closest to attaining it. "Now you're going to find out what kind of men you are." Lombardi told his players, "It takes a lot more of a man to perform as a champion than it did to get him there." The Packers responded with a 13-1 record, with their only loss to the Detroit Lions on Thanksgiving Day. As great as the team's regular season record was, it was meaningless if Green Bay didn't repeat as NFL Champions. (Photograph courtesy of the Tom Pigeon collection.)

To win the 1962 NFL championship, the Packers had to again face their big city rivals from New York. The contest was advertised as a test between Green Bay's good ground game and the Giants prolific passing game. It turned out that two stubborn defenses fought for the championship in the trenches that day. The Packers' defense rose triumphantly by keeping the Giants' high-powered offense out of the end zone all day. Only a Giants special teams touchdown off a blocked punt spoiled the shutout. With the 16-7 victory, the Packers had repeated as NFL champions. (Photograph courtesy of the Tom Pigeon collection.)

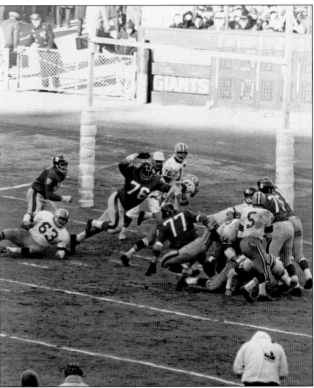

With two world championships and a record of 24-4 over two seasons, Green Bay had returned to the NFL's elite status. Some of the Packer players were now famous wherever football was known, especially with the expanded exposure the sport was receiving in the national media. With their names now worthy of testimonials, personal appearances, and business opportunities, Lombardi tried his best to keep his players' heads from getting too big for their helmets. But as invincible as the Packers felt following the 1962 season, they were unable to avoid the pitfalls of gambling with one of their own. (Photograph courtesy of the *Green Bay Press-Gazette*.)

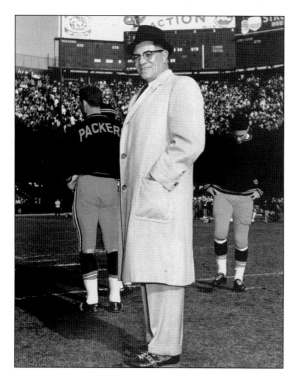

When NFL Commissioner Pete Rozelle suspended Paul Hornung for betting on college and professional football games in April 1963, it meant the Packers offense would be without its leading scorer. Hornung hadn't bet against the Packers, but "transmitted specific information concerning NFL games for betting purposes" according to league officials. With no further review of his rule violations until 1964, Hornung sat out the entire 1963 season. Lombardi refused to go into mourning over the fallen star and replaced him with Tom Moore who gained 658 yards and scored six touchdowns while complementing Jim Taylor in the backfield that season. (Photograph courtesy of the Tom Pigeon collection.)

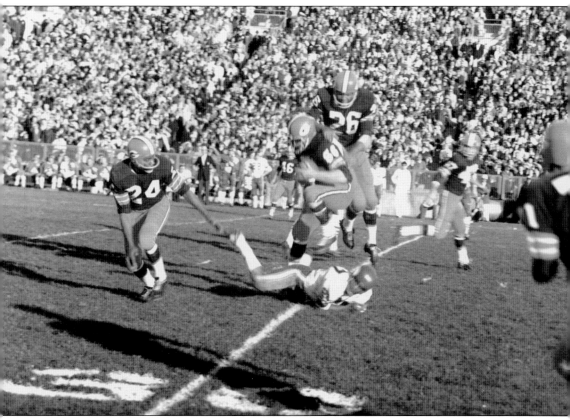

The Green Bay coaching staff worked tirelessly to keep the team hungry and focused each week. With an almost identical squad from the previous year's team, which lost only one game, the 1963 Packers finished the season with only two defeats—both against the archrival Bears. Unable to hurdle Chicago in the standings, Green Bay missed out on postseason play for the first time in four years. It was the best record, 11-2-1, a Packer team ever had that didn't qualify for postseason play—an accomplishment Lombardi loathed. (Photograph courtesy of the Tom Pigeon collection.)

From 1953 through 1963, Jim Ringo was a fixture at center for the Packers. Despite ignoring numerous injuries to start in a record 182-straight games and winning All-Pro honors seven times, the future Hall of Famer may be best remembered for his sudden departure from Green Bay. When Lombardi arrived in 1959, Ringo was the only established All-Pro on a roster filled with underachievers. But it was also well known that Lombardi had little patience for players who made contract demands. So when Ringo and his agent appeared in the coach's office prior to the 1964 season, Lombardi allegedly left the office for five minutes and returned to tell them he'd just been traded to Philadelphia. After he retired in 1967 with the Eagles, Jim Ringo was inducted into the Pro Football Hall of Fame in 1981. (Photograph courtesy of the Green Bay Packers Hall of Fame.)

As had been expected, Hornung (5) was reinstated prior to the start of the 1964 season and struggled to reclaim his superstar form. The Packers also floundered that year, finishing a disappointing 8-5-1. The first seven games that season were filled with injuries, kicking gaffes, and two one-point defeats. The second seven games saw the Packers rebound with a 5-1-1 streak and finish second in the Western Conference. Despite the impressive second-half rebound, Green Bay failed to qualify for the postseason as Lombardi noted in frustration, "we don't put as much emphasis on second place as some teams do." (Photograph courtesy of the Tom Pigeon collection.)

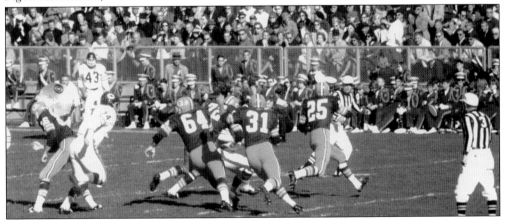

The 1965 Packers were a team of character and resilience—a true reflection of their demanding coach. Green Bay began the season by rededicating new City Stadium as Lambeau Field, after its founder died earlier that year. Despite winning their first six games, the Packers were often outgained and occasionally outplayed. Unable to outright secure the Western Conference crown at season's end, they had to face a talented Baltimore Colts team with an identical 10-3-1 record in a playoff game to decide the conference champion. (Photograph courtesy of the Tom Pigeon collection.)

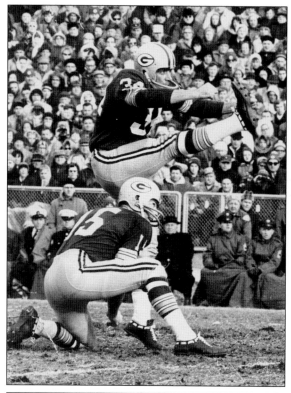

Even though the Colts were without Johnny Unitas and the Packers lost Bart Starr after the first play from scrimmage due to injury, the 1965 Western Conference championship game played out with the intensity of a world championship contest. Green Bay's kicker Don Chandler forced the game into overtime by converting a controversial 22-yard field goal, which many claimed was wide of the vertically-challenged upright. Then with 1 minute and 21 seconds remaining in the sudden-death overtime period, Chandler connected again from 25 yards to win the game and advance the Packers against the defending champion Cleveland Browns for the NFL crown. (Photograph courtesy of the Tom Pigeon collection.)

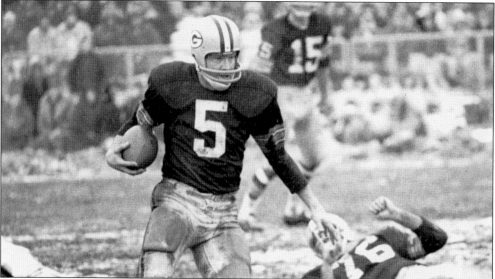

The Packers waged a battle with Jim Brown and the Cleveland Browns on a cold, dreary, mud-filled day at Lambeau Field on January 2, 1966. Bart Starr (15) returned and led the Packers efficient passing attack, while Jim Taylor and Paul Hornung (5) combined for 201 yards rushing. The Packers shut down the defiant Browns, 23-12, and captured their ninth world championship in franchise history. In typical Lombardi fashion, the Green Bay defense held future Hall of Famer Jim Brown to just 50 yards rushing in what became the final game of his legendary football career in a Browns uniform. (Photograph courtesy of the Tom Pigeon collection.)

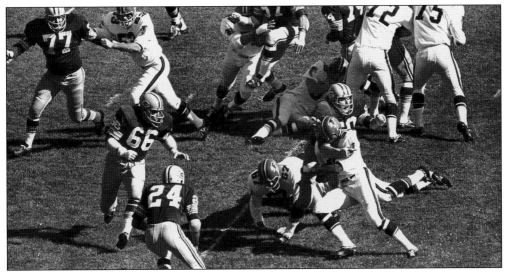

Prior to the start of the 1966 season, the NFL and rival AFL announced that they would eventually merge in time for the 1970 campaign. What caught Lombardi's immediate attention was that the leagues would host a championship game at the end of the current season. With many of Green Bay's star players winding down their careers, the NFL-AFL championship game was another reason for Lombardi to keep his squad motivated. Featuring a ferocious defense and what may have been Bart Starr's finest campaign at quarterback, the Packers rolled through the regular season with a 12-2 record. (Photograph courtesy of the *Green Bay Press-Gazette*.)

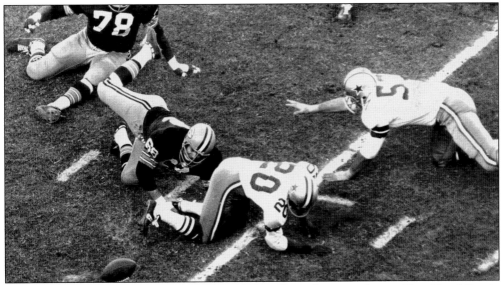

The Packers were poised to win their second consecutive championship on New Years' Day in 1967, but they had to beat Lombardi's former Giants colleague, Tom Landry, and his Cowboys in Dallas. In what became one of his finest hours, quarterback Bart Starr threw four touchdown passes, but it was a game-ending end zone interception by Green Bay's Tom Brown that squashed the Cowboys' hope for a comeback. Winning 34-27, Green Bay earned a ticket to Los Angeles to battle the AFL Champion Kansas City Chiefs and prove their professional football superiority. (Photograph courtesy of the Tom Pigeon collection.)

In what would eventually be christened the Super Bowl, the AFL-NFL championship was played before a crowd of over 63,000 in the Los Angeles Coliseum on January 15, 1967, with the NFL's Packers heavy favorites over the upstart AFL's Kansas City Chiefs. As close as the contest seemed, with Green Bay ahead at halftime, 14-10, the game became a blowout in the second half. The old pros from Green Bay kept the AFL champions scoreless in the final 30 minutes as the Packer defense clamped down and the offense scored three touchdowns to run off with a 35-10 win. (Photograph courtesy of the Tom Pigeon collection.)

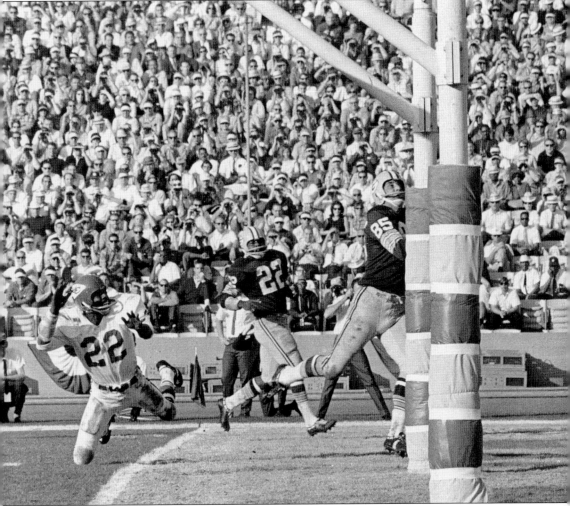

Despite all of the high-profiled superstars playing in the game, Max McGee (85), the Packers' 34-year-old substitute wide receiver became the Super Bowl's first hero. McGee, who had caught just four passes all season and had stayed out well past curfew the night before, was pressed into service when starter Boyd Dowler was injured on the third play of the game. Cutting the Kansas City defense to shreds with seven catches for 138 yards and two touchdowns, including the first touchdown in Super Bowl history, the improbable McGee helped secure the Packers 10th world championship and fourth under Lombardi. (Photograph courtesy of the Tom Pigeon collection.)

One of the greatest Packers of the Lombardi era, Paul Hornung (5), ended up watching Super Bowl I from the sidelines as his stellar career quietly wound down. The Golden Boy was above all a leader to whom the Packers looked to when big plays were needed in big games during the 1960s. As Green Bay's star halfback and place-kicker, Hornung scored 760 points in nine seasons with the green and gold. The 1956 Heisman Trophy winner as a Notre Dame quarterback did more than just score points as one of the most versatile players in pro football history. With a nose for the end zone, Hornung won the NFL's Most Valuable Player award in 1961 and finished his career with 3,711 yards rushing and 1,480 yards receiving, earning him enshrinement in the Pro Football Hall of Fame in 1986. (Photograph courtesy of the Tom Pigeon collection.)

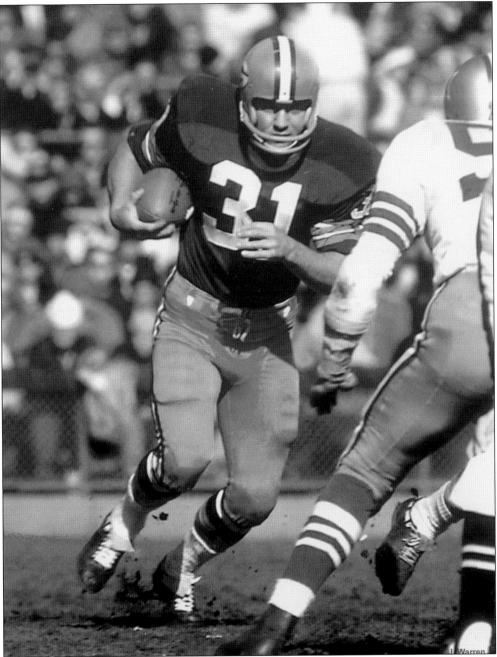

Even though fullback Jim Taylor became the symbol of power in Green Bay's awesome offensive attack, Super Bowl I was his last game in a Packer uniform. Running with a fierceness no one could match over his nine seasons with the Packers, thousand-yard seasons became a specialty for Taylor. He went over 1,000 yards five straight seasons beginning in 1960. In 1962, Taylor had a career year when he rushed for 1,474 yards and was named the NFL Player of the Year. A living testimony to the popular football adage, "when the going gets tough, the tough get going," Taylor was elected to the Pro Football Hall of Fame in 1976. (Photograph courtesy of the Tom Pigeon collection.)

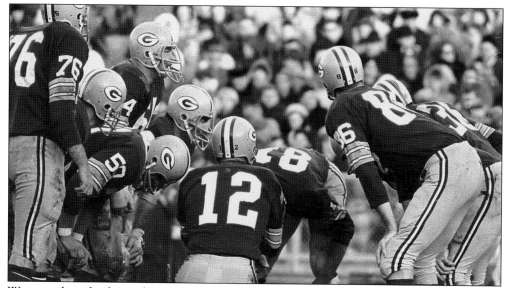

Winning their third-straight world championship in 1967, the Packers got off to a discouraging start when they tied the Lions in the season opener. Even though several key contributors from earlier championship teams were missing in the huddle, Lombardi drove his aging squad of veterans to a 9-4-1 regular season record behind the NFL's top-ranked defense that year. As successful as he had been to that point, it was the NFL championship game rematch against the Eastern Conference champion Dallas Cowboys that would define Lombardi's legacy. (Photograph courtesy of the *Green Bay Press-Gazette*.)

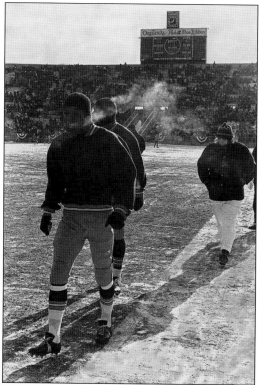

December 31, 1967—A day that will live on famously for any true Green Bay Packer fan as the Ice Bowl. With ticket prices averaging $12 and discouraged ticket hawkers settling for as little as $1.50, a sold-out crowd at Lambeau Field endured 14 below zero temperatures at kickoff to faithfully cheer on Lombardi's Packers. When the Cowboys won the toss, one warm weather reporter quipped, "Dallas won the toss and elected to go home." (Photograph courtesy of the *Green Bay Press-Gazette*.)

Battling against wind chills of 46 degrees below zero, the Packers jumped out to an early 14-0 lead on two touchdown passes from Bart Starr to receiver Boyd Dowler. After a Packer fumble led the way to a Cowboy touchdown, Dallas crawled back into the game. After a field goal late in the second quarter, the Cowboys were down by only four and determined not to let the frozen tundra of Lambeau Field stand in their way en route to Miami, Florida and Super Bowl II. (Photograph courtesy of the Tom Pigeon collection.)

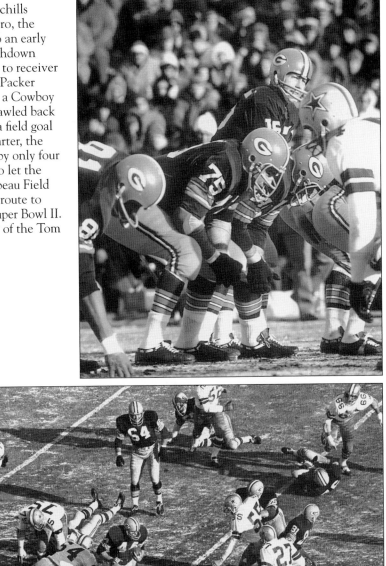

By the third quarter, both offenses stalled as the Packers hung onto their slim lead on the iced-over field. The Cowboys went ahead in the fourth quarter on a Dan Reeves running back option pass to Lance Rentzel—a play that was good for 50 yards and a touchdown giving Dallas the lead, 17-14. With time winding down late into the fourth quarter, the Cowboys defense stood strong and left the Packers with only one chance to win the game. (Photograph courtesy of the *Green Bay Press-Gazette*.)

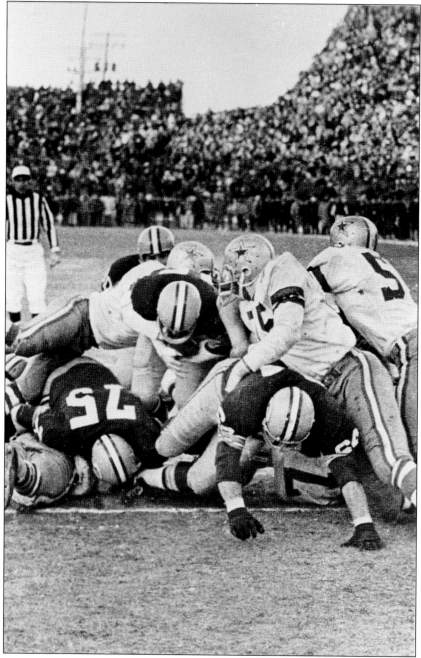

Only 13 seconds remained. Out of timeouts, the Packers were one play away from falling short of winning their third straight NFL championship under Lombardi. Unannounced in the huddle, quarterback Bart Starr took the snap and plunged into the end zone behind guard Jerry Kramer for the winning touchdown. The last second heroics gave the Packers a 21-17 decision over the Dallas Cowboys and an unmatched third straight NFL championship since the 1929–1931 Packers team. The triumph earned Green Bay the right to defend their Super Bowl title against the AFL's Oakland Raiders two weeks later. (Photograph courtesy of the *Green Bay Press-Gazette*.)

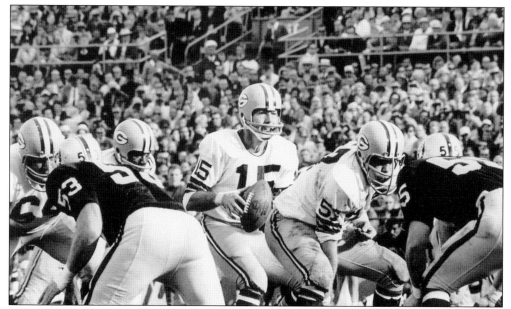

Following the dramatic Ice Bowl, Super Bowl II in Miami was quite anticlimactic. Led by Bart Starr's (15) second consecutive Super Bowl MVP performance and Don Chandler's four field goals, the Packers jumped out to an early lead that they never relinquished. Even though Raiders quarterback Daryle Lamonica responded with a touchdown drive halfway through the second quarter, by halftime the Packers soundly led Oakland 16-7. In the third quarter, Green Bay scored another touchdown and a field goal. When cornerback Herb Adderly intercepted a pass and ran it back for a touchdown in the fourth quarter, it all but secured the victory for the Packers. Green Bay went on to win decisively, 33-14, capturing their second Super Bowl title in as many years. (Photograph courtesy of the Tom Pigeon collection.)

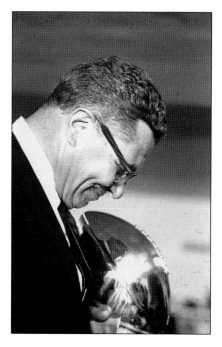

Following the Packers romp over the Oakland Raiders, a joyful Vince Lombardi grasped the championship trophy that would one day bear his name. With rumors running rampant that he would retire after the game, a somber Lombardi told newsmen he wanted to "think about it" for a week or so. Two weeks later, Lombardi handed the coaching reigns over to assistant coach Phil Bengtson. It was the beginning of the end of the Lombardi era and Green Bay's dominant football dynasty. (Photograph courtesy of Corbis Images.)

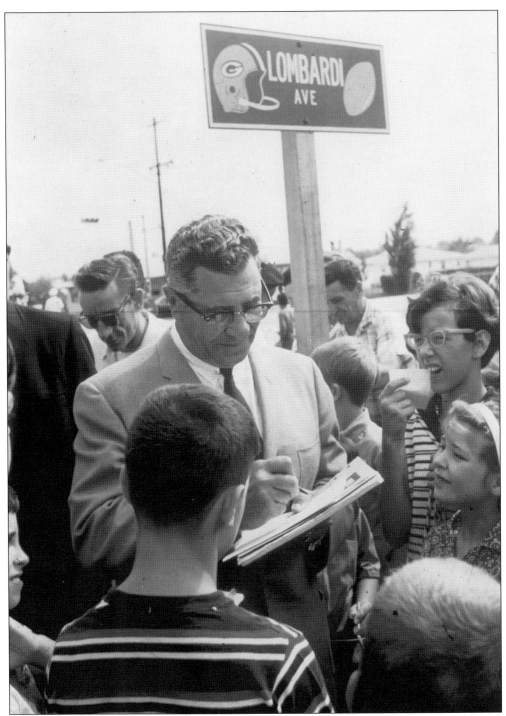

Photograph of Vince Lombardi courtesy of the Neville Public Museum of Brown County.

FOUR

Life after Lombardi
Playing in the Shadows of Legends
1968–1974

When the Packers hosted the Philadelphia Eagles at Lambeau Field to open the 1968 season, it marked the first time in nearly a decade that Vince Lombardi was not on the sidelines as the team's trusted head coach. Instead, as Green Bay's general manager, he watched the action from above Lambeau Field in his personal soundproof room located near the press box.

When the celebrated coach stepped down on February 1, 1968, it seemed to millions of football fans that an important chapter of American history had ended. During his nine years as Green Bay's head coach, the franchise won six division championships, five NFL titles, and the only two Super Bowl contests played to date.

Trying not to overshadow or distract from the Packers players and coaches during the 1968 season, Lombardi reluctantly found himself as a larger-than-life figure in Green Bay and across the country. By walking away as a world champion coach, Lombardi solidified his legacy as one of the greatest to ever pace a professional football sideline. It was a legacy that would loom over Green Bay and taint the team's accomplishments for nearly 30 years.

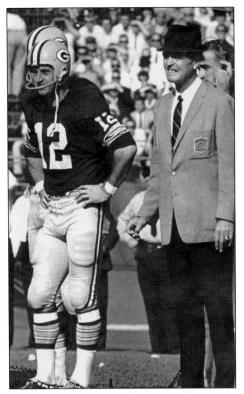

Following their third consecutive world championship in 1967, Lombardi turned over the head coaching duties to his longtime and trusted assistant Phil Bengtson. Unable to replenish the retiring veterans with youthful talent in the draft, the 1968 season ended with a disappointing 6-7-1 record. It's been speculated that if Green Bay had a reliable kicker that year, the team may have fared better, losing six games by a touchdown or less. Regardless, the Packers' decade of domination was quickly dissolving. (Photograph courtesy of the *Wisconsin State Journal*.)

With Phil Bengtson in the forefront as the Packers' head coach, Vince Lombardi grew increasingly restless, bored and frustrated with his general manager responsibilities. At the end of the 1968 season, Lombardi announced his departure from Green Bay to coach and manage the downtrodden Washington Redskins. Under his leadership as head coach, the Packers had an overall 98-30-4 record and accomplished the unprecedented feat of winning five NFL championships in seven years. Lombardi was further immortalized in 1971 by being posthumously elected to the Pro Football Hall of Fame. (Photograph courtesy of the Neville Public Museum of Brown County.)

Without the disciplined guidance of Lombardi steering the Packers for the first time in a decade, Green Bay started the season strong at 5-2, but stumbled down the stretch. Plagued by injuries and inconsistent play, the team clawed its way to a respectable 8-6 record in 1969. (Photograph courtesy of the *Wisconsin State Journal*.)

Regardless of the winning record, by season's end several future Hall of Famers departed or retired, leaving the team scrambling to rebuild its depleted roster. As eager as Packer fans were to recapture the winning ways of Lombardi, it was obvious Titletown had lost its luster. (Photograph courtesy of the *Green Bay Press-Gazette*.)

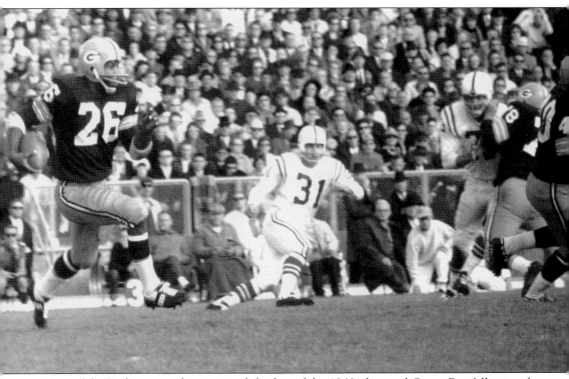

One of the Packers most dominating defenders of the 1960s departed Green Bay following the 1969 season, leaving behind a legacy even he couldn't have imagined when he was drafted out of Michigan State as a running back. When Herb Adderley (26) reported to his first Green Bay training camp in 1961 as the Packers number one draft pick, he had the unenviable task of competing against future Hall of Fame running backs Jim Taylor and Paul Hornung for a starter's spot. Midway through the season however, Lombardi decided to try him as an emergency replacement at cornerback. Using his speed and marvelous instincts, Adderley quickly demonstrated that he had what it took to be an NFL cornerback and immediately took command of the Packers' defensive backfield. Earning All-NFL honors five times while amassing 48 interceptions and returning seven for touchdowns, Lombardi once admitted that he almost made a mistake with Adderley. "I was too stubborn to switch him to defense until I had to," he confessed. "Now when I think of what Adderley means to our defense, it scares me to think of how I almost mishandled him." Adderley played in five Pro Bowl games during the 1960s and was elected to the 1980 Pro Football Hall of Fame class. (Photograph courtesy of the Tom Pigeon collection.)

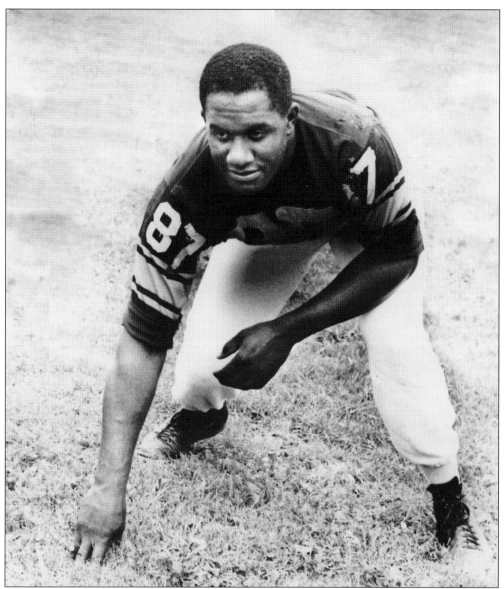

The anchor of the Packers dominating defensive lines retired following the 1969 season, grateful he didn't irrationally react to the news that he was no longer a part of a winning tradition in Cleveland. When the Browns suddenly traded Willie Davis to Green Bay prior to the 1960 season, he briefly considered quitting. Thanks to the strong convincing of Packers coach Vince Lombardi, Davis was quickly assured that Green Bay needed a top-flight defensive end and that he possessed the intangibles—dedication, intelligence, and leadership—that would enable him to become one of the most dominating defenders of the era. Always on the prowl, he recovered 21 fumbles during his career, just one shy of the record, when he retired. Davis' outstanding play earned him selections to five All-NFL teams and the opportunity to play in five consecutive Pro Bowls. Undeniably, Willie Davis was a major factor in Green Bay's winning tradition of the 1960s that included five NFL championships and six divisional titles in eight seasons. His career accolades reached their pinnacle when he was elected to the Pro Football Hall of Fame in 1981. (Photograph courtesy of the Green Bay Press-Gazette.)

Henry Jordan was a fixture at defensive tackle when he retired following the 1969 season. During Green Bay's remarkable run of six divisional titles, five NFL championships and two Super Bowls, Jordan was known as a quick, smart defender who specialized in pressuring the passer. He won All-NFL acclaim five times and also played in four Pro Bowls. In 1995, Jordan became the fifth player elected to the Pro Football Hall of Fame from the Packers' dominant defenses of the 1960s. It was quite an accomplishment for a Cleveland Browns castoff whom Lombardi acquired as a fourth-round draft pick in 1959. (Photograph courtesy of the *Wisconsin State Journal*.)

The Packers' 1970 season was played in a state of mourning. After a summer in and out of Georgetown Hospital, Vince Lombardi succumbed to cancer on September 3, at the age of 57. Over 3,500 people attended Lombardi's funeral, including pallbearers Bart Starr, Paul Hornung, and Willie Davis. Three days after his death, NFL Commissioner Pete Rozelle announced that the Super Bowl trophy would be renamed in Lombardi's honor. (Photograph courtesy of the Transcendental Graphics.)

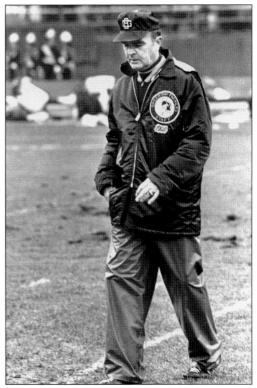

After a turbulent season filled with labor disputes, blowout losses, and the final merger of the AFL and NFL, the Packers finished with another lackluster 6-8 record in 1970. Thoroughly frustrated, Phil Bengtson resigned two days after being shut out in the season finale against Detroit. Disappointed with Bengtson's overall 20-21-1 record during three seasons as Vince Lombardi's handpicked successor, it was obvious the organization and the community craved the high standards of winning established a decade earlier. (Photograph courtesy of the *Green Bay Press-Gazette*.)

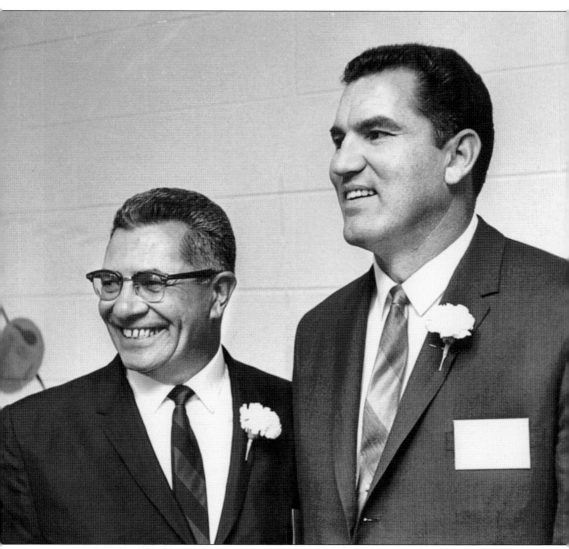

The 1970 season also marked the departure of native Texan Forrest Gregg, who returned home to play with the Dallas Cowboys. Considered by Vince Lombardi as the "finest player I ever coached," many felt Gregg was one of the best to ever play offensive tackle in the history of the game. As a vital part of Lombardi's power sweep strategies that dominated football in the 1960s, Gregg earned the Iron Man tag by playing in a then league record 187 consecutive games with the Packers. As an All-NFL selection for eight straight years between 1960 and 1967, along with nine Pro Bowl appearances, Gregg was enshrined in the Pro Football Hall of Fame in 1977. (Photograph courtesy of the *Green Bay Press-Gazette*.)

The Packers quickly filled their head coaching vacancy in January 1971 when they named Dan Devine head coach and general manager. Considered one of the nation's most successful college coaches at the University of Missouri, hopes were high as the Green Bay faithful proclaimed, "The Pack is Back." (Photograph courtesy of the Neville Public Museum of Brown County.)

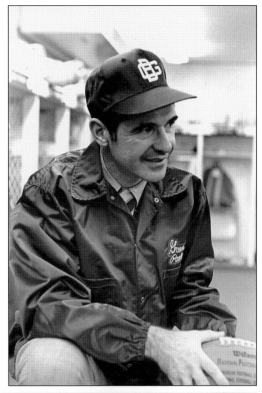

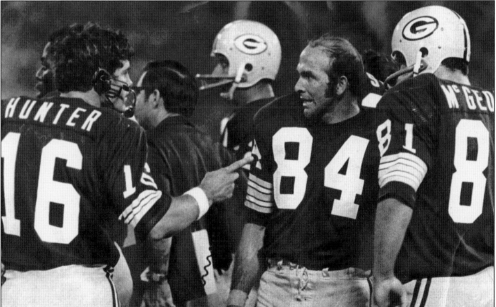

Despite an enthusiastic new coaching staff, the 1971 season saw the veterans of the Lombardi era begin to clash with the youth movement initiated by coach Devine. Despite the roster overhauls, Green Bay struggled to a 4-8-2 record. The season's bright spot was rookie running back John Brockington, who captured Offensive Rookie of the Year honors with 1,105 yards rushing. (Photograph courtesy of the *Wisconsin State Journal*.)

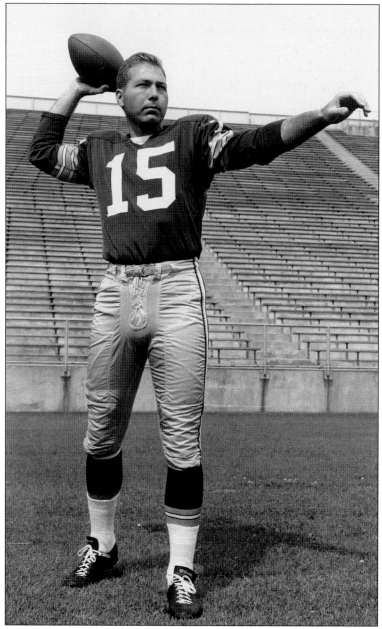

The 1971 season also saw Bart Starr stand behind the center for the last time as a Green Bay Packer quarterback. Considered the cornerstone of consistency during the Lombardi era, Starr's career in Green Bay began in quite an unassuming fashion. Originally drafted by the Packers in the 17th round of the 1956 draft, Starr retired as the most-winning quarterback in NFL history. His golden arm helped direct the Packers to six Western Division titles, five world championships and two Super Bowl victories. His career accolades included MVP honors in the first two Super Bowls, four Pro Bowl selections, the NFL MVP in 1966 and the league's leading passer in 1962, 1964, and 1966. After 16 glorious years as the Packers field general, he was immortalized as a member of the Pro Football Hall of Fame's 1977 class. (Photograph courtesy of the Tom Pigeon collection.)

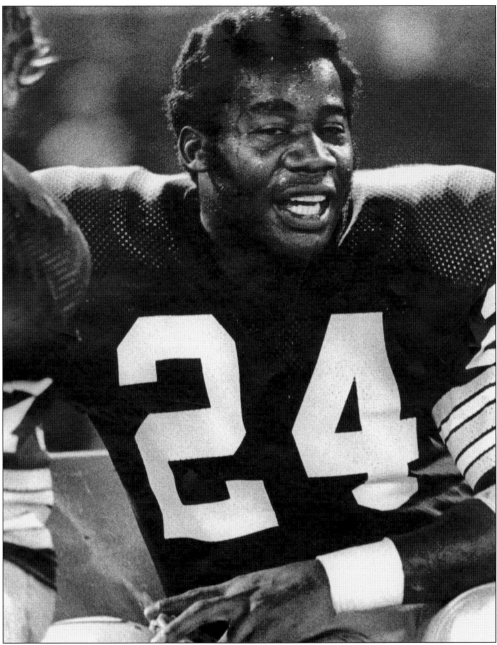

Undrafted, Willie Wood had to seek a tryout and prove his worth before the Packers accepted him as a free agent in 1960. He became a starter in his sophomore 1961 season and held that job for more than a decade until his retirement following the 1971 campaign. Wood compiled impressive statistics with 48 career interceptions that were returned for 699 yards and two touchdowns. An eight-time Pro Bowl selection, Wood received first or second team All-NFL honors nine times in a nine-year stretch from 1962 through 1970. After his 1989 induction, Wood held the distinction of being only one of six undrafted free agents to be elected to the Pro Football Hall of Fame. (Photograph courtesy of the *Wisconsin State Journal*.)

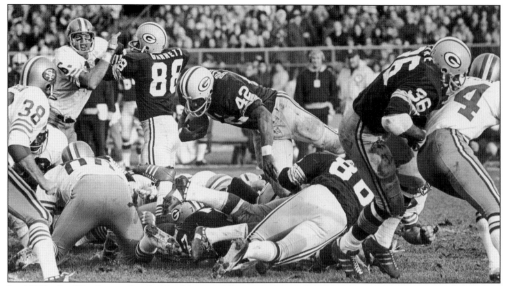

In 1972, the "Pack was Back." Led by workhorse running backs John Brockington (42) and the recently acquired MacArthur Lane (36), the duo formed one of the best running tandems in the NFL—second behind only the Dolphins Larry Csonka and Mercury Morris in total rushing yards. Along with a sturdy defense that featured rookie standout Willie Buchanon, the Packers clinched their first division title since 1967 with an impressive 10-4 record. (Photograph courtesy of the *Wisconsin State Journal*.)

As the Packers' youth movement showed signs of promise, the success of that season was short-lived. The Packers traveled to Washington, D.C. to play their first postseason football game in five years against the Washington Redskins, keepers of the best record in the NFC that season. After a Chester Marcol field goal early in the second quarter gave Green Bay an early 3-0 lead, the Redskins scored 16 unanswered points and eliminated the Packers from the playoffs on Christmas Eve, 16-3. (Photograph courtesy of the *Wisconsin State Journal*.)

The 1972 season also saw the career end for one of Green Bay's fiercest competitors. Ray Nitschke was the heart and soul of the great Packers defenses in the 1960s. The first defensive player from the Packers' dynasty years to be elected to the Hall of Fame in 1978, Nitschke earned either first or second team All-NFL honors seven times in eight years from 1962 to 1969. In addition to being a hard-hitting tackler, he was excellent in pass coverage as his 25 lifetime interceptions attest. Regardless of his intense demeanor on the field, Nitschke became one of Green Bay's favorite sons after his retirement. Always available for a photograph or autograph, his phone number was continually listed in the local Green Bay phone book in the event a fan wanted to talk Packer football with the living legend after his retirement. (Photograph courtesy of the *Green Bay Press-Gazette*.)

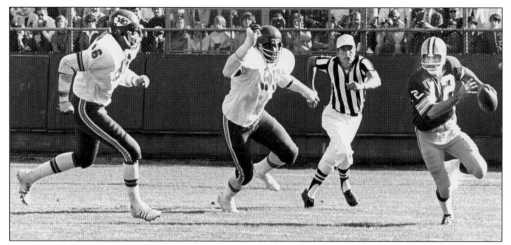

The Packers' youth movement scrambled to avoid a setback and attempted to repeat as Central Division champions in 1973, but they were unable to avoid the inevitable. Seemingly in a tailspin from their postseason loss the previous season to the Redskins, the team never seemed to gain any positive momentum on either side of the ball. Stagnant and in second place by mid-October with a 2-1-2 record, three consecutive offensive performances of anemic proportions left Green Bay with three embarrassing losses and searching for answers in December. (Photograph courtesy of the *Wisconsin State Journal*.)

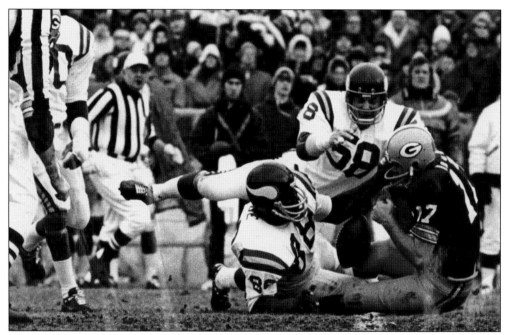

Attempting to address the team's inability to move the ball on offense, coach Devine wavered between Jerry Tagge (17), Scott Hunter and Jim Del Gaizo as the team's starting quarterback. It seemed if a Packer quarterback hadn't thrown an incomplete pass that season, it was because they'd already been chased down and sacked. Devine's three-quarterback rotation combined for six touchdowns and 17 interceptions en route to a disappointing 5-7-2 record and a third place finish in the division. (Photograph courtesy of the *Wisconsin State Journal*.)

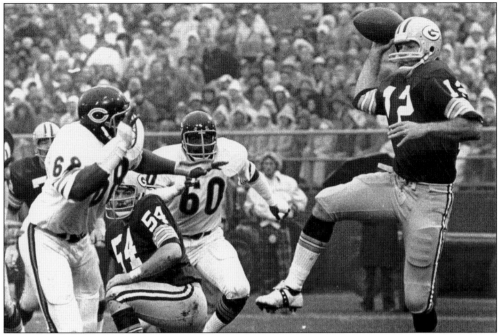

Desperate for a quality field general, coach Devine traded for Los Angeles Rams' quarterback John Hadl (12) after the sixth game of the 1974 season. Considered one of the most infamous trades in team history, the Packers gave up five draft picks—a first, second and third in 1975 and a first and third in 1976—for the 34-year-old veteran, who many considered past his prime. (Photograph courtesy of the *Wisconsin State Journal.*)

Hadl's touted arrival in Green Bay was short-lived. Questions quickly resurfaced about his fading arm strength after throwing eight interceptions and just three touchdowns in the final seven games of the 1974 season. He would play just a season and a half for the Packers, throwing 11 touchdowns and 29 interceptions. (Photograph courtesy of the *Wisconsin State Journal.*)

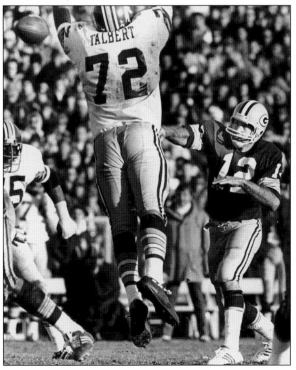

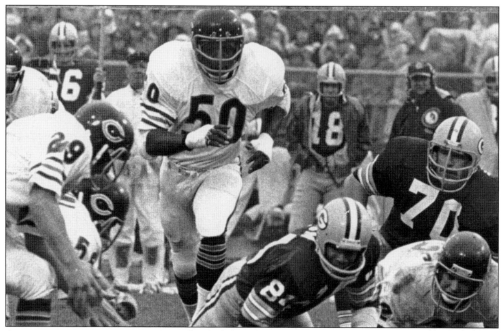

A new veteran presence at quarterback didn't prevent the Packers from stumbling down the stretch in 1974. Still in the playoff race entering December, with a contending 6-5 record, Green Bay lost its final three games and finished with a disappointing 6-8 record. (Photograph courtesy of the *Wisconsin State Journal*.)

For the second straight year, the Packers finished ahead of only the Chicago Bears in the NFC Central Division standings. As another season played out with sub-par results, Devine realized he was losing support with the team's executive committee and began shopping for a new job. (Photograph courtesy of the *Wisconsin State Journal*.)

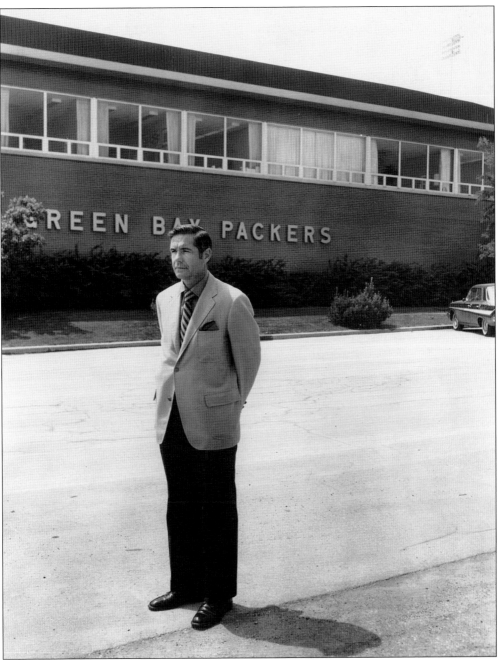

Amid rumors he had already accepted the Notre Dame head coaching position, Dan Devine resigned on December 16 as Green Bay's head coach and general manager. In his four seasons as the Packers' head coach, 10 quarterbacks threw passes for Devine—an auspicious legacy. Trying desperately to find a replacement for Bart Starr, Devine tried trades, draft picks, and the waiver wire, but he couldn't find a savior in Green Bay. Ironically, when he left the Packers to coach Notre Dame, Devine helped tutor a young gunslinger from eastern Pennsylvania named Joe Montana. (Photograph courtesy of the Neville Public Museum of Brown County.)

Photograph of Bart Starr courtesy of the *Wisconsin State Journal*.

FIVE

Grasping at Greatness
More Tradition than Victories
1975–1991

It had been eight years since Vince Lombardi barked plays into the Green Bay huddle from the sidelines of Lambeau Field, but the franchise continued to be haunted by his unparalleled legacy. After his handpicked replacement and a successful college coach were unable to recapture the team's championship form, Packer executives looked to one of Lombardi's brightest and most successful players.

Ironically, Dan Devine replaced an aging Bart Starr at quarterback during the 1971 season only to have the golden arm replace him as the Packers youthful head coach in 1975. Despite having little coaching experience, except for a season as Devine's quarterback coach in 1972, Green Bay was excited about what the living legend would bring to the Packers sidelines.

On Christmas Eve in 1974, Bart Starr, one of the most successful quarterbacks in professional football history, accepted the challenge to lead the Packers out of the NFL doldrums as the franchise's head coach and general manager. Starr asked for "the prayers and patience of Packer fans everywhere We will earn everything else" at his initial press conference. It was a statement Packer fans took to heart as they eagerly awaited the results. (Photograph courtesy of the *Wisconsin State Journal*.)

By restoring a positive attitude within the organization, Starr gave the Packers hope during his first year as head coach. His rookie campaign on the sidelines started with four straight losses as the Packer faithful relied on their patience. An upset victory against the Cowboys in Dallas, 19-17, on October 19, gave Starr his first win as coach, but Green Bay fell to 1-8 by mid-November. Ending the 1975 season on a positive note, the surging Packers won three of their final five games and finished with a 4-10 record. (Photograph courtesy of the *Wisconsin State Journal*.)

Even though they improved to 5-9 in 1976, the team finished yet again in the NFC Central Division cellar. As the quarterback position began to resemble a revolving door reminiscent of the Devine era a few seasons prior, Starr traded the ineffective John Hadl to the Houston Oilers for a relatively unknown backup quarterback who would wear green and gold for nearly a decade. Showing signs of his phenomenal arm strength and passing accuracy, Lynn Dickey (10) struggled with injuries and interceptions upon his arrival in Green Bay. (Photograph courtesy of the *Wisconsin State Journal*.)

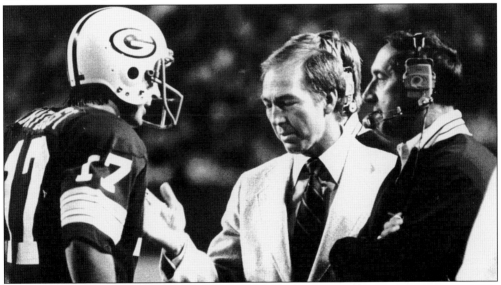

Handicapped with injuries, the 1977 Packers were yet again among the worst teams in the NFL. Posting a horrendous 4-10 record with only the lowly Tampa Bay Buccaneers keeping them out of last place in the NFC Central Division for a third consecutive year, the team seemed to be stuck in a labyrinth of losing. Quarterbacks Lynn Dickey and David Whitehurst (17) literally handcuffed the Packers' hopes as they combined for 21 interceptions and just six touchdown passes—ranking the team offense 27th out of 28 teams that season. (Photograph courtesy of the *Wisconsin State Journal*.)

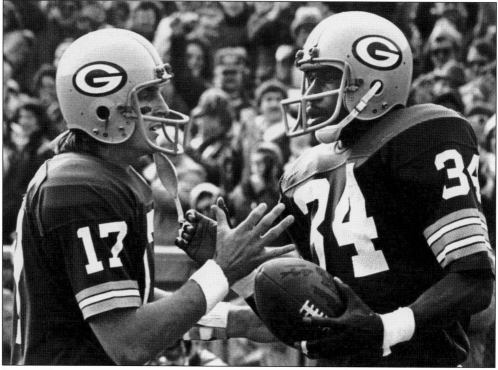

Despite the previous season's woeful outcome, hopes rose again in Green Bay as the rebuilt Packers started the 1978 season with an astounding 6-1 record and the team's best start in a dozen years. The fruits of Bart Starr's roster rebuilding seemed to have paid off as the 1978 team hardly resembled the group of players he inherited in 1975. (Photograph courtesy of the *Wisconsin State Journal*.)

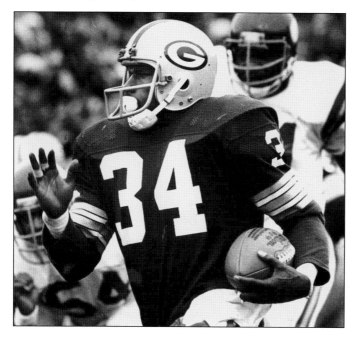

Several players had career years that season including Terdell Middleton (34) who rushed for 1,116 yards in Green Bay's revitalized ground game. The young and resurgent Packers raced to an early three-game advantage in the NFC Central Division before costly mistakes led to a second-half collapse that jeopardized their postseason aspirations. (Photograph courtesy of the *Wisconsin State Journal*.)

As the schedule toughened up, the Packers won only one of their next six games. After a crucial victory over the Tampa Bay Buccaneers, the 8-5-1 Packers still had a shot at the NFC Central title. Losing both of their final two games and finishing the season at 8-7-1, Green Bay was in a first place tie with the Minnesota Vikings. After losing out on a tiebreaker, the Packers were forced to watch the playoffs from the comfort of their own homes following the 1978 season. (Photograph courtesy of the *Wisconsin State Journal*.)

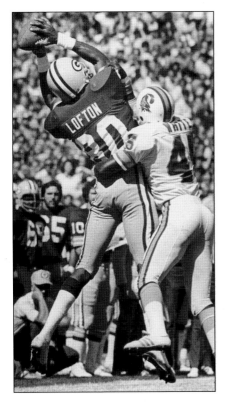

Even though the season ended in disappointment, the Packer faithful seemed increasingly hopeful that the team's fortunes would continue to turn around thanks to the strong performance of their first-round draft choice, wide receiver James Lofton. As graceful as he was athletically gifted, the Stanford graduate gave the Packers an offensive weapon that hadn't been seen in Green Bay for many years. (Photograph courtesy of the *Wisconsin State Journal*.)

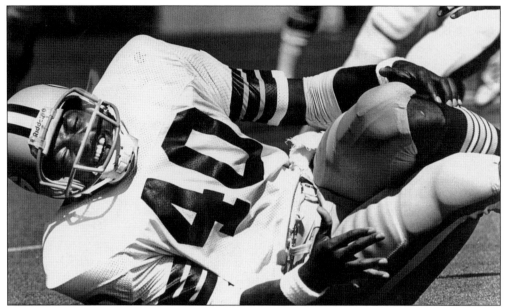

Marked by one injury epidemic after another, Green Bay's 1979 squad was mired in defensive inadequacies. With the NFL's worst rushing defense that year, the underachieving Packers allowed opponents to relentlessly run up and down the field, unabated. This was a major reason the team finished a disappointing 5-11. Despite beating the Minnesota Vikings for the first time in five years and hosting a thrilling victory on Monday Night Football against the New England Patriots, Starr's coaching abilities began to be questioned as the team failed to build on its success from the previous season. (Photograph courtesy of the *Wisconsin State Journal.*)

Before the 1980 season even began, it seemed first-round draft pick Bruce Clark had the right idea when he bolted directly for the Canadian Football League never playing a down for the Packers. Green Bay regrouped and started strong by outlasting the Chicago Bears in an overtime thriller in the season opener. But with 27 players on injured reserve during the course of the year, the team was unable to replenish its roster and finished in last place with a 5-10-1 record. (Photograph courtesy of the *Wisconsin State Journal.*)

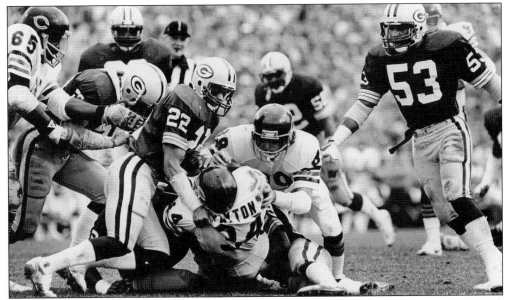

The 1981 Packers were a team of streaks. Starting the season with an abysmal 2-6 record, Green Bay began to play strong football and won six of its next seven games. With a chance to make the playoffs heading into the regular-season finale against the New York Jets, the Packers postseason hopes were immediately dashed after a 28-3 loss. Green Bay finished tied for second place in the NFC Central Division that year, with an 8-8 regular-season record, but a trade during mid-season helped elevate the Packers offense to new heights. (Photograph courtesy of the *Wisconsin State Journal*.)

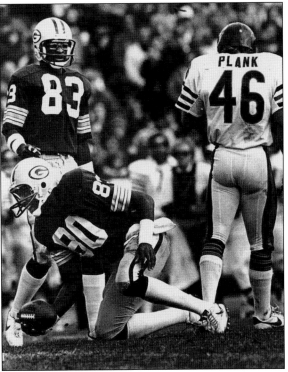

One of the biggest reasons for the Packers successful 6-2 turnaround halfway through the season in 1981 was the acquisition of All-Pro wide receiver John Jefferson (83) from the San Diego Chargers. With Jefferson and James Lofton (80) in the same lineup, Green Bay possessed the most feared receiving combination in the league. It seemed coach Starr was finally building a winner in Green Bay. (Photograph courtesy of the *Wisconsin State Journal*.)

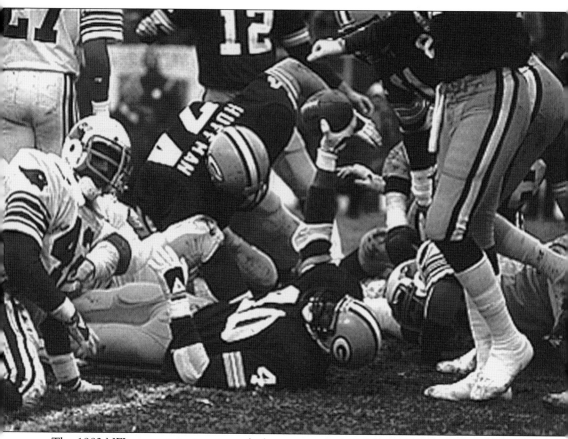

The 1982 NFL season was interrupted after two weeks by a player walkout. When the players returned, the season was shortened to nine games. Because of the games lost to the players strike, the NFL expanded its postseason into a Super Bowl tournament and qualified 16 teams for the playoffs. After posting two come-from-behind wins to open the season, the Comeback Pack finished with an impressive 5-3-1 record and qualified for the playoffs for the first time since 1972. Green Bay hosted their first playoff game at Lambeau Field since the Ice Bowl. Led by Eddie Lee Ivery's (40) two first-half touchdowns, Green Bay was comfortably ahead 28-9 against the St. Louis Cardinals when the halftime whistle blew. En route to record-setting days, Lynn Dickey's four touchdown passes and John Jefferson's 148 receiving yards helped the Packers rout the Cardinals 41-16. Even though the Packers had an impressive 466-yard offensive effort the following week against the Cowboys, they bowed out, 37-26, in Dallas and were eliminated from the Super Bowl tournament. (Photograph courtesy of the *Wisconsin State Journal*.)

An energy and excitement surrounded the Packers training camp in 1983 – the likes of which had not been seen since the Lombardi era. Green Bay fans of all ages clamored for the chance to see their latest heroes in green and gold practice for the upcoming season. As popular as the players were following the team's first playoff berth in 10 years, they continued to participate in one of the Packers' oldest traditions that summer. (Photograph courtesy of the Wisconsin State Journal)

Believed to have begun in 1961 by Vince Lombardi, Packers training camp has offered young fans the unique opportunity to lend their bicycles to players for the trek to and from the practice field. Running alongside the bike, each adopted kid has the opportunity to bond with the pedaling Packer—an interaction that's as intimate as the organization's relationship with the community itself. (Photograph courtesy of the *Wisconsin State Journal*.)

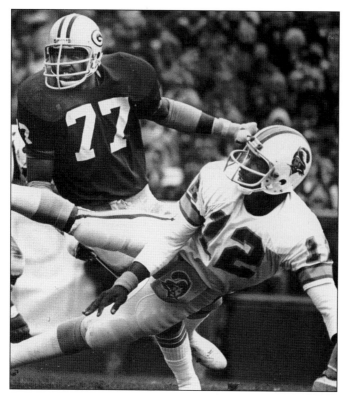

Reminiscent of the NFL's football wars with the AAFC and AFL, Green Bay and the league fought a bitter battle with the upstart United States Football League for players, fans, and media attention following the 1982 season. The USFL's alluring incentive-laden contracts pulled many established players from the NFL. The Packers were unable to avoid the roster purging and lost their defensive standout, Mike Butler (77), who immediately jumped to the upstart spring league. (Photograph courtesy of the *Wisconsin State Journal.*)

Other than the loss of Butler, the Packers' 1983 defense was almost identical to the squad that made the playoffs the previous year. Defensive standouts John Anderson (59), Mike Douglass (53), Tim Lewis, Mark Lee and Johnnie Gray returned in hopes of guiding Green Bay to consecutive playoff appearances. But the defensive unit never seemed to solidify and forced the team into several high-scoring shootouts while almost setting an NFL record for most yards allowed in a single season. (Photograph courtesy of the *Wisconsin State Journal.*)

The Packers shootout abilities were showcased for a national television audience against the defending world champion Washington Redskins at Lambeau Field in 1983. In one of the greatest football games ever played on Monday Night Football, the two teams combined for 95 points and 1,025 yards of offense. Ironically, the game came down to a stroke of luck when Washington's Mark Moseley, who set an NFL record for accuracy the previous season, missed a 39-yard field goal attempt on the last play of the game, allowing the Packers to escape with a 48-47 win. (Photograph courtesy of the *Green Bay Press-Gazette*.)

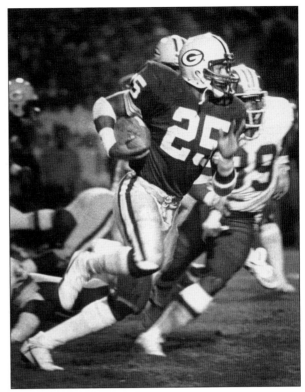

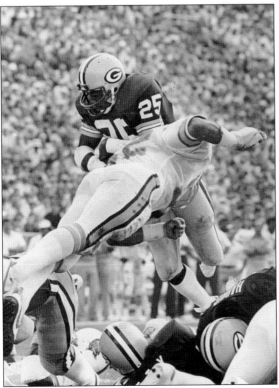

Despite the Monday night victory over the defending world champions, the Packers seemed mired in mediocrity during most of the 1983 season. Green Bay played in five overtime games, nearly alternated wins and losses and were never more than a game above or below the .500 mark all season. Regardless of their prolific offense, it seemed the Packers couldn't cross over into the NFL's elite class of Super Bowl contenders that year. (Photograph courtesy of the *Wisconsin State Journal*.)

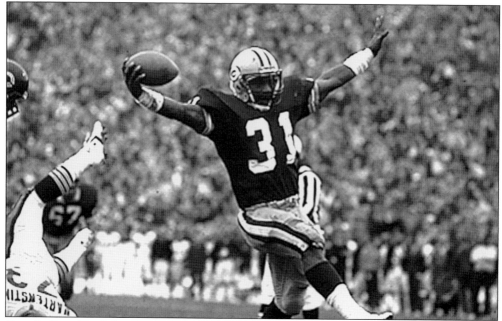

Overshadowed by defensive shortcomings, the Packers' 1983 offense was one of the most potent in team history. They posted a single-season club record of 429 points behind the talents of quarterback Lynn Dickey, running back Gerry Ellis (31), tight end Paul Coffman, kicker Jan Stenerud, and wide receivers James Lofton and John Jefferson. Amassing 6,172 yards and 52 touchdowns, Green Bay was poised for its second consecutive postseason appearance for the first time since Lombardi's Super Bowl teams of the 1960s. (Photograph courtesy of the *Wisconsin State Journal*.)

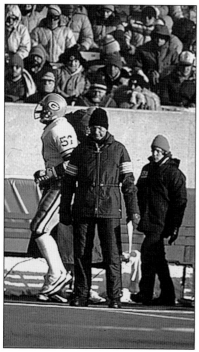

With the playoffs clearly in their grasp, the Packers went into Chicago for the season finale. After a late fourth quarter comeback by the Bears, Starr and the Packers mismanaged the game clock and lost in the closing seconds. Eliminated from the postseason and finishing the year yet again with an 8-8 record, Bart Starr was relieved of his coaching duties the very next day. (Photograph courtesy *Wisconsin State Journal*.)

On Christmas Eve 1983, Green Bay decided to replace Starr with his former teammate and fellow Lombardi disciple, Forrest Gregg. After maneuvering the Cincinnati Bengals into Super Bowl XVI in 1981, hopes were high when the second Lombardi protégé donned the Packers head coaching position. At his inaugural press conference, a confident Gregg declared, "I took this job to field a winning team. That will happen." (Photograph courtesy of the *Wisconsin State Journal*.)

The Gregg era in Green Bay started on a positive note in 1984 with a win in the season opener against the St. Louis Cardinals. Despite several key injuries during the first half of the schedule, Gregg's prediction almost came to fruition when the Packers rebounded from a 1-7 start to win seven of their last eight games. Many thought finishing with an 8-8 record was quite an accomplishment after starting the season so poorly. (Photograph courtesy of the *Wisconsin State Journal*.)

After the 1984 season, Gregg cleaned house and released or traded many of Starr's veteran players in an attempt to rebuild the team with younger talent. Mired yet again with injuries and other off-the-field legal complications, the 1985 season mirrored the previous season's results. The Packers started slow at 3-6 before mounting a strong finish and winning five of their last seven contests to again close at 8-8. During that season, Lambeau Field hosted one of the greatest and most memorable games in team history. (Photograph courtesy of the *Wisconsin State Journal.*)

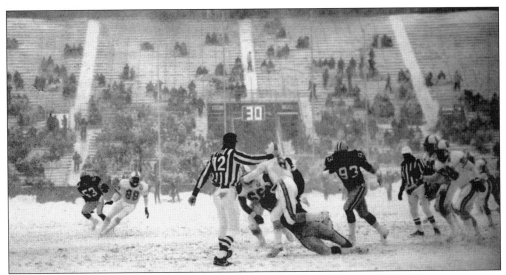

Affectionately known as the Snow Bowl, the Buccaneers and future Hall of Fame southpaw, Steve Young (8), were ill-prepared to play in the biggest snowstorm in Packers' history on December 1, 1985. With over 10 inches of fallen snow, winds swirling at 30 miles per hour and wind chills dipping below negative seven degrees, the smallest crowd ever at Lambeau Field watched the Packers apply their home-field advantage to a new extreme. As the statistics and scoreboard reflected, the game was no contest as Tampa Bay lost in the white haze, 21-0, and was outgained in total yards, 512-65. (Photograph courtesy of the *Green Bay Press-Gazette.*)

Before the start of the Packers' 1986 season, the competing USFL had folded after just three years of financial futility. As NFL franchises scrambled for the rights to released players, Green Bay acquired notable team contributors such as running back Paul Ott Carruth and quarterback Chuck Fusina. By training camp, Coach Gregg was convinced the time had come to completely overhaul the Packers roster and replace the aging veterans. After sweeping personnel changes, the youthful and inexperienced Packers got off to a frustrating 0-6 start. Suffering major growing pains, the team endured an awful 4-12 season. (Photograph courtesy of the *Wisconsin State Journal*.)

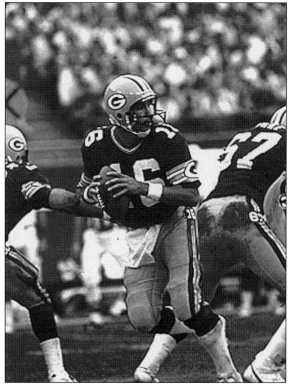

Blown out in more than half of their games, it seemed the only time the Packers received national attention that year was when defensive end Charles Martin received a two-game suspension for maliciously body slamming Chicago Bears quarterback Jim McMahon into the ground. As Green Bay endured another season marred in embarrassing defeats and scandals, former Wisconsin Badgers quarterback Randy Wright (16) enjoyed a career year as just the second quarterback to throw for over 3,000 yards in franchise history. But by season's end, one of Wright's favorite offensive targets was the subject of a scandal that ultimately ended his decorated career in Green Bay. (Photograph courtesy of the *Wisconsin State Journal*.)

Surrounded by swirling sexual assault accusations, superstar wide receiver James Lofton became expendable in Green Bay by season's end. Traded to the Los Angeles Raiders prior to the 1986 season, Lofton was eventually acquitted of the charges and continued his Hall of Fame career with the Buffalo Bills, Los Angeles Rams and Philadelphia Eagles. He finished his playing career in 1993 with 14,004 career receiving yards—an NFL record at the time of his retirement. (Photograph courtesy of the *Wisconsin State Journal*.)

Two games into the 1987 schedule, the players walked out and went on strike. The league responded by using replacement players. During the Scab Games, the Packer replacements went 2-1, and the Packers sat at 2-2-1 when the regular players returned on October 25. By the end of the 1987 season, the Packers stumbled to a 5-9-1 record and coach Forrest Gregg left Green Bay to fill the coaching vacancy at his college alma mater, Southern Methodist University. After only four seasons, Gregg departed Green Bay with a disappointing 25-37-1 record and a depleted roster of underachieving, injury-riddled talent. (Photograph courtesy of the *Wisconsin State Journal*.)

Nineteen days after Gregg's departure, the Packers announced Lindy Infante as the tenth head coach in the franchise's history. Recognized throughout the NFL as a brilliant offensive innovator with the Cleveland Browns, Packer hopes now hinged on the team's first head coach without ties to Vince Lombardi since 1974. (Photograph courtesy of the *Green Bay Press-Gazette*.)

Plagued by turnovers, kicking problems and undisciplined play, the Packers lost 12 of their first 14 games under Infante in 1988. After a two game winning streak to finish out the season, the Packers' 4-12 record ignited hopes for a resurgence in 1989. One of the bright spots that year was the impressive play of their number one draft pick, Sterling Sharpe (84). With 55 catches, he set the Packers rookie record for receptions in a season. By the time he retired following the 1994 season due to injury, Sharpe held numerous Packer receiving records. (Photograph courtesy of the *Green Bay Press-Gazette*.)

With the second overall pick in the 1989 NFL draft, the Packers were poised to draft an immediate impact player. Amongst rampant rumors of steroid use, Green Bay chose Michigan State offensive tackle Tony Mandarich (77). Sandwiched between the Cowboys' choice of Troy Aikman at number one and the Lions' Barry Sanders at number three, Mandarich seemed the perfect fit to rejuvenate the Packers' stagnant offensive line. But after a lengthy contract holdout during training camp, the Incredible Bulk never quite caught up to his reputed draft-pick potential in Green Bay. (Photograph courtesy of the *Eau Claire Leader-Telegram*.)

When Bob Harlan was named president and chief executive officer of the Green Bay Packers in June of 1989, he promptly announced, "I want to move this franchise ahead in every area." As a member of the team's front office since 1971, he realized the Packers were nearing the end of another futile decade and thirsting for respect. With their glory days becoming more mythical after each passing season, Harlan was committed to establishing a new winning agenda in Green Bay. (Photograph courtesy of the *Green Bay Press-Gazette*.)

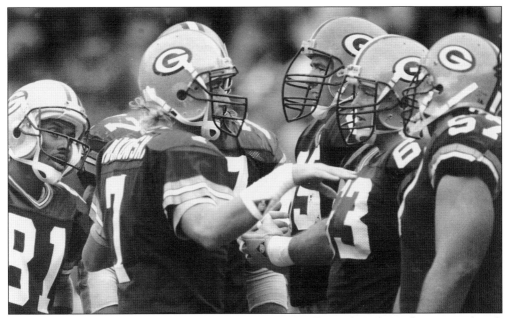

With the hiring of the team's new president and CEO, the Packers seemed to respond with miracles every Sunday during the 1989 season. With 10 games decided by four points or less, the Cardiac Pack set a league record of four one-point victories. Even the biggest Green Bay cynics realized that for one glorious season, the Pack was back. (Photograph courtesy of the *Green Bay Press-Gazette*.)

The season's most dramatic come-from-behind victory came against the Bears and defined the Packers' superb season. Green Bay hadn't beaten Chicago in five years when Don Majkowski (7) rolled to his right on fourth down and threw a 14-yard touchdown pass to Sterling Sharpe with only seconds remaining. An official ruled that Majkowski stepped over the line of scrimmage, and it was only after an instant-replay review that the decision was reversed and the Packers could proclaim sweet victory. To this day, the game has been immortalized as the infamous After Further Review contest. (Photograph courtesy of the *Green Bay Press-Gazette*.)

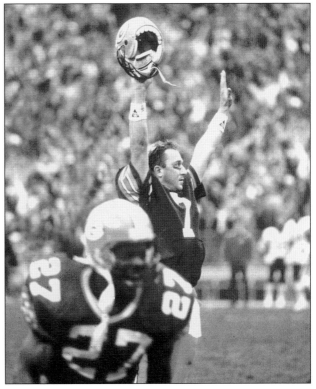

The consistent play of defensive standouts Tim Harris, Johnny Holland, Brian Noble (91), Mark Murphy, Dave Brown, and Chuck Cecil down the stretch rallied the Packers to win five of their last six games in 1989. Finishing 10-6, the Packers and their fans were forced to sit in front of their television screens on Christmas Day hoping the Cincinnati Bengals would deliver a holiday miracle to Green Bay by beating the rival Vikings. But Minnesota held on to win the game and the division tiebreaker, keeping the Packers at home for yet another postseason. (Photograph courtesy of the *Green Bay Press-Gazette*.)

In 1990, subsequent high hopes for a postseason evaporated 11 games into the promising season. After Majkowski was injured in week 10 and diagnosed with a season-ending rotator cuff tear, the contending Packers, with a 6-5 record, called upon backup quarterbacks Anthony Dilweg and Blair Kiel to keep the team's playoff hopes alive. But as the Packers offensive line allowed a team-record 62 sacks that season, Green Bay finished on a five-game losing streak and a disappointing 6-10 record that year. (Photograph courtesy of the *Green Bay Press-Gazette*.)

The Packers continued to decline in 1991. Losing several close contests, it was obvious the Packers were no longer the talented team that pulled out those last second victories a couple of years before. Finishing the season with a 4-12 record, the Packers dismissed Lindy Infante as head coach following the season finale. After four years and a 24-40 record, Infante was looking for work and the Packers were in search of a new head coach. (Photograph courtesy of the *Green Bay Press-Gazette*.)

Prior to Infante's firing, Bob Harlan had made a change that steered the franchise into a new era of success. When he was hired as the new executive vice president and general manager, the Packers gave Ron Wolf full authority to run the team's football operations. With a stellar reputation for building winning franchises with the New York Jets, Tampa Bay Buccaneers, and Oakland Raiders, it was now his responsibility to build a winner in downtrodden Green Bay. His first task would be to find a head coach with a winning pedigree and reputation for nurturing young talent into champions. (Photograph courtesy of the *Green Bay Press-Gazette*.)

Photograph of Mike Holmgren is courtesy of Chip Manthey.

SIX

The Return to Excellence
Reclaiming Titletown
1992–1996

Hired as the Packers' executive vice president and general manager in November 1991, Ron Wolf was given the daunting responsibility of turning around an organization that had suffered through 15 losing seasons in the 24 years since Vince Lombardi's departure. A month and a half into his term, Wolf made the decision to build the Packers around a successful assistant coach and offensive coordinator from the San Francisco 49ers' Super Bowl dynasty. Regardless of the fact that Mike Holmgren had no head coaching experience in either college or the NFL, Wolf sensed that his attitude and dedication to winning were exactly what the Packers were lacking. "You can feel the leadership," Wolf said. "He has that kind of cocky confidence that Bill Walsh has. When you sit and talk to him, you're going to feel a toughness and a charisma."

When Mike Holmgren was named the Packers 11th head coach in team history on January 11, 1992, it was obvious from the start that Green Bay's fortunes would turn around. It was now only a matter of getting the right players to fill the team's roster.

As Green Bay began to build for the future, former Commissioner Pete Rozelle's visions of parity became a reality in the NFL. By taking advantage of the recently enacted Plan B free agency system, Wolf quickly restocked the Packers roster, but knew he needed to find a marquee player to build the franchise around.

In what would define his legacy in Green Bay, Wolf's first big trade as general manager sent a first-round draft choice, 17th overall, to Atlanta for an unknown and undisciplined backup quarterback named Brett Favre. Wolf understood fully that his future, as well as that of coach Mike Holmgren, might be linked to the success or failure of the feisty 22-year-old who spent the majority of his rookie season riding the Falcons bench. (Photograph courtesy of the *Green Bay Press-Gazette*.)

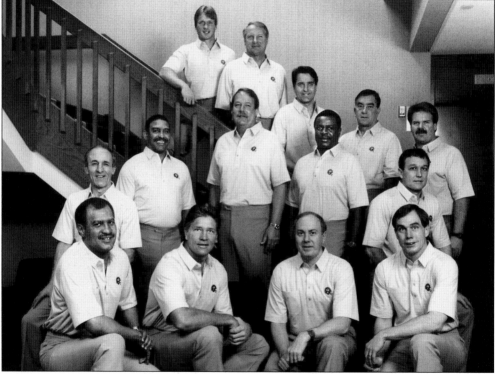

As Wolf acquired players to replenish the roster, Holmgren wasted no time assembling his stellar coaching staff. By bringing aboard Sherman Lewis and Ray Rhodes from San Francisco to be his offensive and defensive coordinators, he was able to instill the 49ers' successful coaching philosophies. Along with Andy Reid as the tight ends/assistant offensive line coach, Jon Gruden as the offensive assistant/quality control coach, holdover defensive backs coach Dick Jauron and Steve Mariucci to mentor Favre as the quarterbacks coach, Holmgren recruited an initial staff that would yield five future NFL head coaches in the years to come. (Photograph courtesy of the *Green Bay Press-Gazette*.)

The Packers began the 1992 season with two straight losses, but as slowly as the Holmgren era started in Green Bay, it was the events that transpired on Sunday, September 20, 1992, that redefined the franchise forever. When starting quarterback Don Majikowski was forced out of the season's third game with a broken ankle, unproven Brett Favre (4) was called upon to replace him. In the first of many exhilarating come-from-behind victories, Favre engineered a 24-23 win against the Cincinnati Bengals during the game's final seconds. (Photograph courtesy of the Tom Pigeon collection.)

Tutoring Favre, Holmgren spent the remainder of the season harnessing the quarterback's superior arm strength and unrivaled raw talent. Once he settled in as the starter, Favre guided the Packers to six straight wins and within sight of the playoffs before losing the season finale at Minnesota. In his inaugural season, Holmgren directed Green Bay to a respectable 9-7 record. In the team's history the only other head coaches who had winning records in their first season were Curly Lambeau and Vince Lombardi. (Photograph courtesy of the *Eau Claire Leader-Telegram*.)

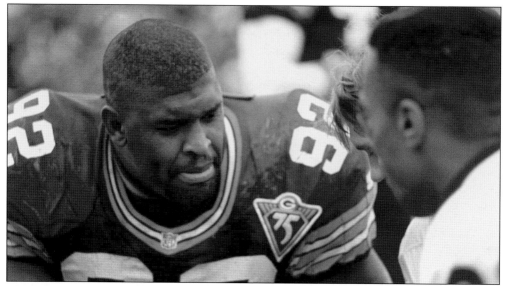

The NFL's smallest city landed the biggest free agent prior to the start of the 1993 season when defensive end Reggie White (92) signed a four-year, $17 million contract with the Packers. His arrival in Green Bay immediately erased the stigma that nobody wanted to play on the frozen tundra of Lambeau Field. Upon his arrival, White proclaimed to the rest of the league what Packer fans sensed was building the previous season, "I think if this team could get back to a winning attitude, to a championship," White said, "I think it could capture the heart of America." (Photograph courtesy of the *Eau Claire Leader-Telegram*.)

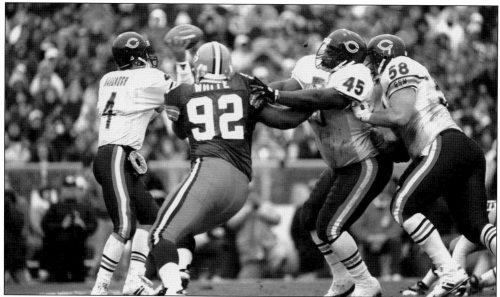

White's impact was immediate on and off the field. With No. 92 leading the Pack, their defensive ranking rose from 23rd in 1992 to 2nd in 1993. As Green Bay's newest superstar, he helped to mentor the rookies and provided some much needed leadership in the locker room. As Green Bay fought for a playoff spot during the final weeks of the season, it was the presence of the Minister of Defense that made the rest of the NFL realize that winning had returned to the league's most decorated franchise. (Photograph courtesy of the *Eau Claire Leader-Telegram*.)

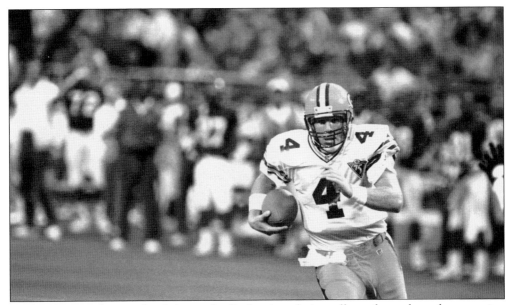

With White anchoring the defense, the Packers' explosive offense focused on the emerging talents of Favre (4). After starting the season 1-3, the Packers' quarterback went on to orchestrate seven wins during the next nine games—including two three-game winning streaks. Along with his favorite target Sterling Sharpe, who set an NFL single-season record of 112 catches, Favre and the Packers were in the Central Division title hunt going into the final weeks of the season. (Photograph courtesy of the *Eau Claire Leader-Telegram*.)

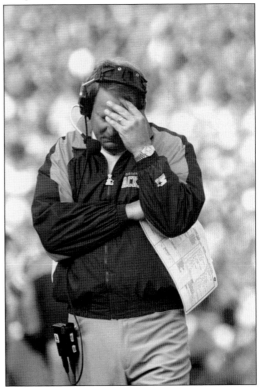

As the Packers entered the December portion of their schedule, they battled the Lions for the Central Division lead. The Bears made it a three-team race going into the last four weeks of the season after whipping the Packers in Chicago. Green Bay recovered and pulled out a win in San Diego only to stumble the following week in the Metrodome against the Vikings. As much progress as the Packers had made in 1993, their postseason fate completely relied on the outcome of their last home game against the Los Angeles Raiders. (Photograph courtesy of the *Eau Claire Leader-Telegram*.)

The subzero temperatures couldn't freeze the frenzied fan enthusiasm at Lambeau Field as the Packers dominated the visiting Raiders. As Green Bay marched towards victory to clinch their first playoff berth since the strike-shortened 1982 season, the game took on an additional significance with the debut of the Lambeau Leap. As inauspicious as it was spontaneous, the Lambeau Leap originated after LeRoy Butler (36) forced a fumble from Raiders quarterback Vince Evans that Reggie White recovered. After running with the ball for 10 yards, White tossed it back to Butler, who ran the remaining 25 yards into the end zone. Butler then made the lunging leap into the south bleachers and inviting arms of crazed fans. Still riding the wave from the Lambeau Leap, the Packers attempted to win their first postseason game in a non-strike year since Super Bowl II. In a wild-card playoff game hosted in Detroit, Brett Favre proved yet again why he was a future Hall of Famer. In the game's final minute, he scrambled and threw a 40-yard, across-the-body, across-the-field touchdown strike to Sterling Sharpe as the Packers miraculously defeated the Lions 28-24, earning Green Bay a trip to Dallas. Unable to continue their winning ways the following week, the Packers fell soundly to the eventual Super Bowl champion Cowboys, 27-17. Regardless, their first playoff appearance in 10 years rejuvenated the community and the entire state of Wisconsin as they anxiously awaited the next year. (Photograph courtesy of Harmann Studios.)

During the 1994 season, the Packers announced they would begin hosting all of their home games at the newly renovated Lambeau Field in 1995. After 62 straight years of playing in Milwaukee, the team would no longer split their home schedule between Green Bay and southeastern Wisconsin. In their Milwaukee finale on December 18, 1994, the Packers were down to their final seconds against the Atlanta Falcons, trailing 17-14. Unable to find an open receiver, Brett Favre took a leap of faith that landed him in the end zone, giving the Packers an exhilarating 21-17 come-from-behind victory. (Photograph courtesy of the Tom Pigeon collection.)

Behind a dominating defense led by Reggie White, LeRoy Butler, and Sean Jones in 1994, the Packers won seven of their eight contests at home. The winning mystique of home-field advantage had returned to Lambeau Field with a vengeance. The Packers registered their third consecutive 9-7 record and second straight trip to the postseason—the first time that had happened since the Titletown days of 1966 and 1967. (Photograph courtesy of the Green Bay Press-Gazette.)

Hosting their first playoff game in a non-strike year since the Ice Bowl, the Packers beat Detroit and shut down future Hall of Famer Barry Sanders in impressive fashion. Holding the NFL's most feared running back to minus one yard rushing in 13 attempts, the Packers stayed undefeated at home in the postseason with a 16-12 win. Despite the Packers' dominating defensive effort against the Lions for the second straight year, the Packers playoff run ended in Dallas, with a 35-9 defeat to the Cowboys. (Photograph courtesy of Harmann Studios.)

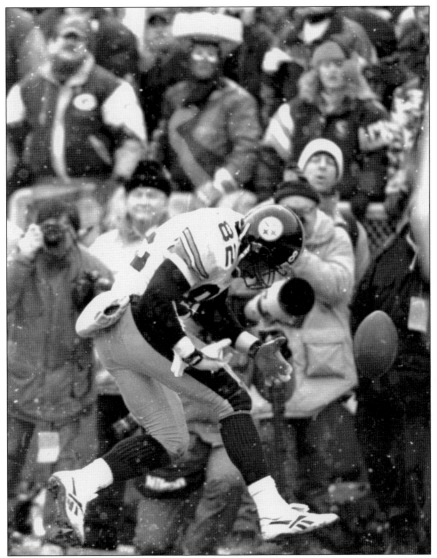

The 1995 Packers put together one of their finest seasons in franchise history. By winning five of their previous six games going into the season finale on Christmas Eve, they were on the verge of capturing their first NFC Central Division crown since 1972. But it wasn't until the Pittsburgh Steelers' wide receiver Yancey Thigpen (82) dropped a fourth-down pass in the end zone with 16 seconds remaining, that the Packers secured their first outright division championship in 23 years. Finishing the season 11-5, Green Bay began the postseason by clobbering the Atlanta Falcons 37-20 in the first round of the playoffs at Lambeau Field. Building on that triumph, the Packers mounted one of the premier performances in their postseason history. As 10-point underdogs in San Francisco against the powerhouse 49ers, the Packers' swarming defense and playmaking offense jumped out to a 21-0 lead en route to dethroning the defending Super Bowl champions, 27-17. The Packers postseason path found them yet again in Dallas. Leading 27-24 after the third quarter of the NFC championship game, Green Bay's Super Bowl dreams began to evaporate. The Cowboys took control in the fourth quarter and won 38-27 on their way to their third Super Bowl championship in four years. (Photograph courtesy of the *Green Bay Press-Gazette*.)

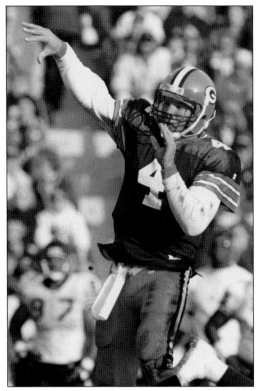

Favre was a runaway MVP winner in 1995 after completing 63 percent of his passes for 38 touchdowns and an NFL-best 4,413 yards passing. Collecting 69 of a possible 88 votes from a nationwide panel of sportswriters and broadcasters, Favre became the first Packer to win the MVP award since quarterback Bart Starr in 1966. It was the first of three consecutive MVP awards for the Mississippi gunslinger, all but ensuring him a spot in Pro Football's Hall of Fame. (Photograph courtesy of the *Eau Claire Leader-Telegram.*)

Almost from the point their 1995 season ended in Dallas, the Packers had only one goal in mind during the 1996 season and that was winning Super Bowl XXXI. Green Bay worked vigorously during the off-season to implement the tools to realize their destiny. But it was an announcement by Brett Favre in May that almost derailed their Super Bowl run before it even began. After admitting he was entering a clinic to be treated for substance abuse, Favre declared at his first news conference, "This year it is the Super Bowl or bust." (Photograph courtesy of the *Green Bay Press-Gazette.*)

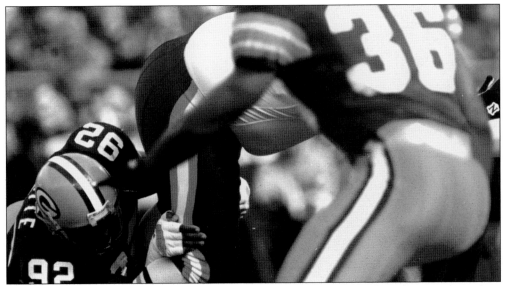

Green Bay made a statement to the rest of the NFL at the start of the season by outscoring their first three opponents 115-26 in dominant fashion. Behind Reggie White (92) and LeRoy Butler (36), the Packers' key off-season acquisitions of Santana Dotson, Bruce Wilkerson, and Eugene Robinson quickly contributed to Green Bay's stifling defensive unit. The Packers jumped out to an impressive 8-2 start heading into a Monday night match-up against the defending Super Bowl champion Cowboys in Dallas. (Photograph courtesy of the *Eau Claire Leader-Telegram*.)

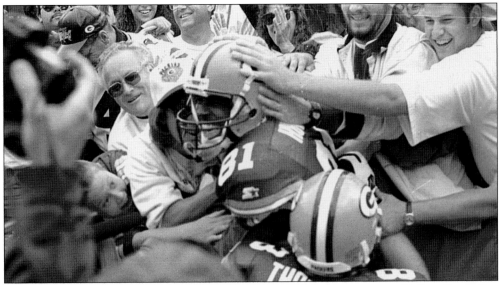

Hoping to send a definitive message of their newfound dominance against Dallas, Green Bay instead raised doubts about whether they were ready to ascend to the next level of football superiority. As the Cowboys used seven field goals to beat the Packers, 21-6, the loss could have deflated the green and gold. Instead it made them more determined than ever. Week after week, role players and special teams contributors, including return specialist Desmond Howard (81), gave Green Bay unlimited weapons to win their last five games while outscoring their opponents, 162-45 during the winning streak. (Photograph courtesy of the *Green Bay Press-Gazette*.)

As every player on the roster contributed to the Packers' dominating performances, several younger players began to share the spotlight with the high-profiled superstars and standouts. Thanks in part to the efforts of second year wide receiver Antonio Freeman (86), Green Bay rallied together as a team to capture their second consecutive NFC Central Division title. Their 13-3 regular-season record earned them home-field advantage throughout the playoffs and ensured that the road to Super Bowl XXXI would go through Lambeau Field. (Photograph courtesy of the Green Bay Press-Gazette.)

Earning a first-round bye, Green Bay's initial task in the playoffs was to beat the San Francisco 49ers at Lambeau Field. On a chilly, rain-soaked afternoon in front of a record 60,787 fans with only three no-shows, the Packers defense knocked future Hall of Fame quarterback Steve Young (8) out of the game and set the tone early when Desmond Howard ran back a 71-yard punt return for a touchdown in the first quarter. (Photograph courtesy of Harmann Studios.)

As the Packers ran up a 21-0 margin in the second quarter, the 49ers, led by backup quarterback Elvis Grbac, took advantage of two turnovers and cut Green Bay's lead to 21-14. But the Packers quickly responded by scoring on their next possession and later forced a special teams fumble that led to the final 35-14 victory. Confident, the Packers and their loyal fans were ready to host a rematch of the previous season's NFC championship game against the Cowboys in Lambeau Field. (Photograph courtesy of the Tom Pigeon collection.)

The rematch never materialized as the upstart Carolina Panthers eliminated the Cowboys. After a typical Wisconsin snowstorm blanketed Lambeau Field prior to the NFC championship game, local residents arrived at the stadium with shovels in hand, ready to partake in another unique Green Bay tradition. For decades, fans have eagerly assisted in clearing snow out of the stands before home games at near minimum wage just to share in the magical surroundings of Lambeau Field's frozen tundra. (Photograph courtesy of the Wisconsin State Journal.)

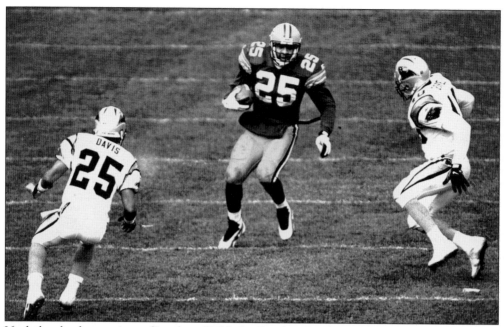

Unshaken by the mystique of Lambeau Field, the Carolina Panthers arrived and gave the Packers plenty of problems in the early going of the NFC championship game. Intercepting Favre twice in the first quarter, Carolina took an early 7-0 lead. But the resilient Packers evened the score during the first play of the second quarter when Favre connected with Dorsey Levens (25) on a 29-yard strike along the far right edge of the end zone. After converting a Favre fumble at mid-field into a field goal, the pesky Panthers regained the lead, 10-7. (Photograph courtesy of Harmann Studios.)

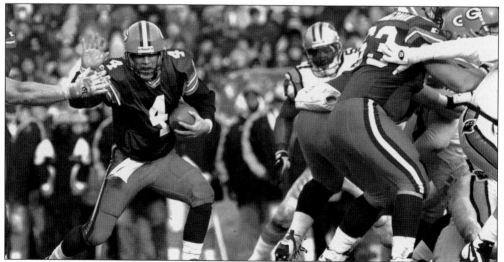

The Packers responded with a 71-yard touchdown drive and by halftime had a seven point cushion, leading 17-10. After the two teams traded field goals at the start of the third quarter, it was all Green Bay in the second half. Favre hit wide receiver Antonio Freeman with a memorable 66-yard touchdown pass that gave the Packers a comfortable 27-13 lead. The touchdown seemingly broke the Panthers spirit that brisk afternoon, as Carolina didn't reach the end zone again. (Photograph courtesy of Harmann Studios.)

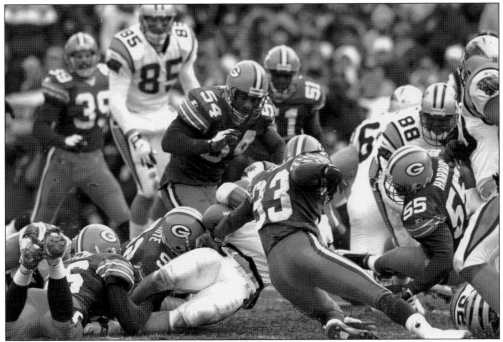

With the 30-13 win, Green Bay successfully traversed the road to Super Bowl XXXI through Lambeau Field, despite frigid temperatures reminiscent of the Packers' last championship game in Green Bay during the Ice Bowl. As time wound down, the Lambeau loyalists were determined to soak up the Packers' first Super Bowl berth in nearly 30 years. (Photograph courtesy of Harmann Studios.)

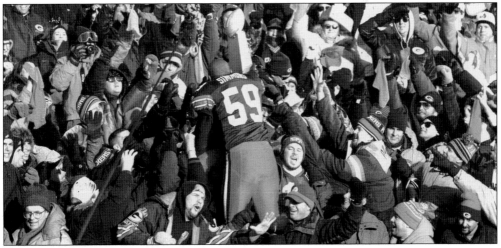

After finishing the season a perfect 10-0 at Lambeau Field, the Packers erased 29 years of frustrating football on that subzero Sunday afternoon. In a celebration for the ages, the Packers and their dedicated fans were poised to taste the sweet nectar of an NFL championship for the first time since Lombardi strolled the Green Bay sidelines. (Photograph courtesy of Harmann Studios.)

The Packers arrived in New Orleans, the home of Super Bowl XXXI, as 14-point favorites against the AFC champion New England Patriots. Green Bay had the opportunity to win their unprecedented 12th world championship as an organization. As owners of the most championship titles in NFL history, with the Bears ranking second with nine, the Giants with six, the Cowboys, Redskins and 49ers with five and the Lions, Steelers and Browns with four apiece, the Packers would have to avoid the many distractions of Super Bowl week to achieve their destiny. (Photograph courtesy of the *Wisconsin State Journal*.)

Playing less than an hour from his hometown of Kiln, Mississippi, Brett Favre made good on his preseason declaration of Super Bowl or bust when he took the field on the Packers' first offensive possession. As Ron Wolf had predicted when he acquired the young gunslinger from Atlanta in 1992, the Packers' hopes and successes were directly hinged on the performance of No. 4. (Photograph courtesy of Tom Pigeon collection.)

Sensing a Patriots blitz, Favre audibled on Green Bay's second play from scrimmage and hit wide receiver Andre Rison on a wide-open post pattern with a 54-yard touchdown strike. On the Patriots next possession, cornerback Doug Evans intercepted a Drew Bledsoe pass that Green Bay converted into a field goal and an early 10-0 lead. (Photograph courtesy of Harmann Studios.)

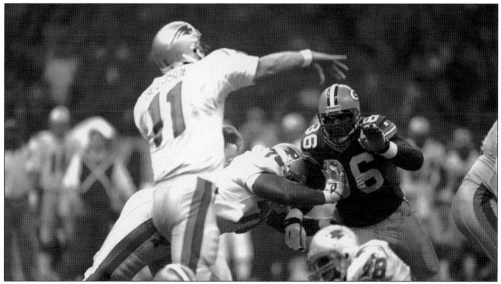

New England refused to be intimidated by the Packers' quick scores as they turned the tide in their favor. The Patriots quarterback, Drew Bledsoe (11), wasted no time and drove down the field in six plays to pull within three points on a touchdown pass to Keith Byars. With just over two minutes remaining in the first quarter, New England pulled ahead, 14-10, on another Bledsoe touchdown pass to tight end Ben Coates. The Patriots had gained the lead as the highest-scoring first quarter in Super Bowl history came to an end. (Photograph courtesy of Harmann Studios.)

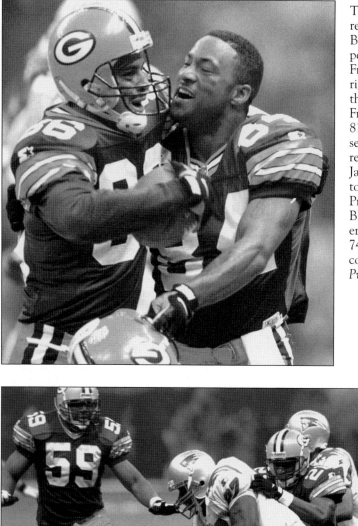

The Packers quickly regained the lead when Brett Favre lofted a perfect spiral to Antonio Freeman (86) along the right sideline. Outrunning the Patriots defender, Freeman scored on the 81-yard touchdown pass, setting a new Super Bowl record. After another Chris Jacke field goal, Favre took advantage of a Mike Prior interception of Drew Bledsoe and lunged into the end zone after a nine play 74-yard drive. (Photograph courtesy of the *Green Bay Press-Gazette*.)

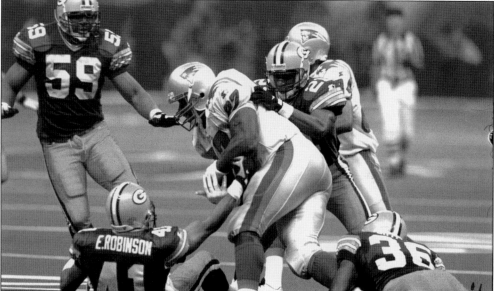

Taking a 27-14 lead into the locker room at halftime, the Packers maintained that lead until late in the third quarter. The Patriots rallied when running back Curtis Martin made a magnificent 18-yard run up the middle of the Green Bay defense and scored with 3:27 remaining in the third quarter to cut the Packers' lead to 27-21. New England's hope for their first Super Bowl victory was short-lived as they launched the ensuing kickoff to the awaiting Packers return squad. (Photograph courtesy of Harmann Studios.)

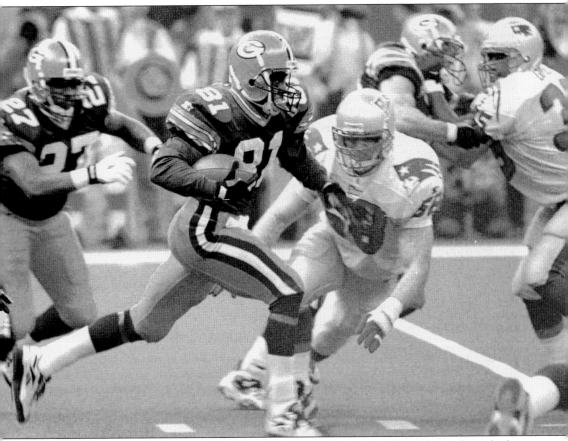

Green Bay's return specialist, Desmond Howard, received the kickoff and burst through the center of the Packers' well-blocked wedge. After juking Patriots kicker Adam Vinatieri, Howard bolted into the end zone for a 99-yard touchdown return, the longest in Super Bowl history. After a two-point conversion to Mark Chmura, the Packers took a 35-21 lead into the final quarter and essentially extinguished any hopes of a Patriots rally.

Thanks to his historic performance of returning four kicks for 154 yards and six punts for an additional 90 yards, Desmond Howard's 244 combined return yards set a new Super Bowl record and earned him the game's MVP award—a first for a special teams player. (Photograph courtesy of the *Green Bay Press-Gazette*.)

With a 14-point lead, the Packer defense took over in the fourth quarter and showed the world why they deserved to be crowned professional football's world champions. Led by Reggie White (92), who recorded a Super Bowl record three sacks, New England was kept to a measly 253 yards passing and 43 yards rushing—including 42 yards from 1,000-yard rusher Curtis Martin. The Packers held onto their 14-point margin and won Super Bowl XXXI. (Photograph courtesy of the *Green Bay Press-Gazette*.)

For the first time in 29 years, the Packers were once again champions of the football world. By holding off coaching legend Bill Parcells and the resilient AFC champion Patriots, Green Bay captured its unprecedented 12th world championship and third Super Bowl victory in franchise history. Reminiscent of the Lombardi teams of the 1960s, the Packer squad, caught up in sentimental tradition, carried their victorious coach off the field, triumphant. Coach Mike Holmgren was then escorted through a cavalcade of photographers to greet his championship team. (Photograph courtesy of Harmann Studios.)

By displaying impressive consistency on both sides of the ball during the playoffs and Super Bowl, the Packers documented their superiority by outscoring their three opponents, 100-48, in a postseason sweep. With their victory in New Orleans, Green Bay joined an exclusive group of teams with three or more Super Bowl victories—Dallas, San Francisco, Pittsburgh, Oakland, and Washington. (Photograph courtesy of the *Green Bay Press-Gazette*.)

As architects of the Packers' return to prominence, Bob Harlan, Ron Wolf, and Mike Holmgren graciously accepted the Vince Lombardi trophy from NFL Commissioner Paul Tagliabue (pictured far left). Their partnership led the Packers to the pinnacle of professional football's elite. Their record spoke for itself with six consecutive winning seasons, Green Bay's first such parlay since the 1960s, a club-record five straight playoff berths, three consecutive NFC Central Division championships, two NFC championships in a row and a definitive victory in Super Bowl XXXI. (Photograph courtesy of Harmann Studios.)

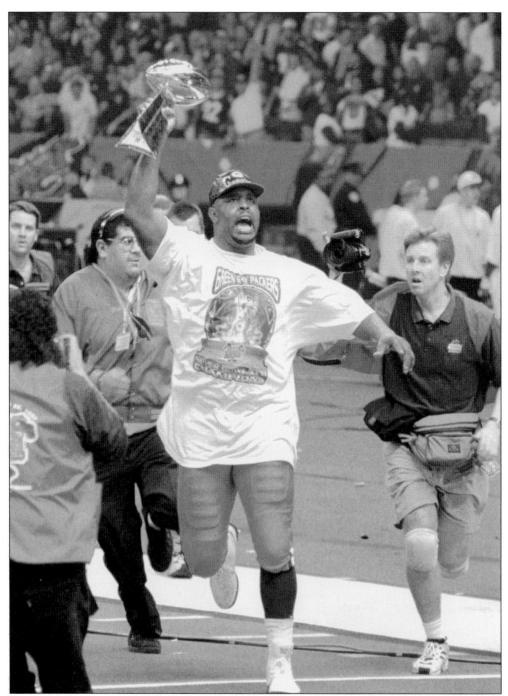

Fulfilling the prediction he made while signing with Green Bay back in 1993, Reggie White proved the Packers had a winning attitude and could win a championship while capturing the heart of America. During the post-game celebrations Reggie White triumphantly returned the Lombardi Trophy back to its original home—Titletown, U.S.A. (Photograph courtesy of the *Green Bay Press-Gazette*.)

Mathematics for
Machine Technology

Mathematics for
Machine Technology

ROBERT D. SMITH

ISBN: 0-8273-1198-2
LIBRARY OF CONGRESS CATALOG CARD NUMBER: 73-2157

Printed in the United States of America
Published simultaneously in Canada
by Nelson Canada,
A Division of International Thomson Limited